THE GIRL WHO SPOKE
WITH PICTURES

of related interest

Autism Heroes
Portraits of Families Meeting the Challenge
Barbara Firestone, Ph.D.
Forewords by Teddi Cole and Gary Cole and Catherine Lord, Ph.D.
Photographs by Joe Buissink
ISBN 978 1 84310 837 5

A Will of His Own
Reflections on Parenting a Child with Autism—Revised Edition
Kelly Harland
Foreword by Jane Asher, President of the National Autistic Society
ISBN 978 1 84310 869 6

The Hidden World of Autism
Writing and Art by Children with High-functioning Autism
Rebecca Chilvers
Foreword by Uttom Chowdhury
ISBN 978 1 84310 451 3

Families of Adults with Autism
Stories and Advice for the Next Generation
Edited by Jane Johnson and Anne Van Rensselaer
Foreword by Stephen Edelson, Autism Research Institute, San Diego
ISBN 978 1 84310 885 6

Autism through Art

THE GIRL WHO SPOKE
WITH PICTURES

EILEEN MILLER

ILLUSTRATIONS BY KIM MILLER

FOREWORD BY ROBERT NICKEL, M.D.

Jessica Kingsley Publishers
London and Philadelphia

First published in 2008
by Jessica Kingsley Publishers
116 Pentonville Road
London N1 9JB, UK
and
400 Market Street, Suite 400
Philadelphia, PA 19106, USA

www.jkp.com

Library of Congress Cataloging in Publication Data

Miller, Eileen, 1962-
 The girl who spoke with pictures : autism through art / Eileen Miller ; foreword by Robert Nickel.
 p. cm.
 ISBN 978-1-84310-889-4 (pb : alk. paper) 1. Miller, Kim, 1988- 2. Autistic children--Language. 3. Autistic children--Biography. 4. Child artists--Biography. 5. Drawing--Therapeutic use. I. Title.
 RJ506.A9M58 2008
 618.92'89156--dc22

 2008001465

British Library Cataloguing in Publication Data

A CIP catalogue record for this book is available from the British Library

ISBN 978 1 84310 889 4

Printed and bound in the United States by
Thomson-Shore, 7300 Joy Road, Dexter, MI 48130

In loving memory of Mike L. Simmons—
fellow author, neighbor, and beloved friend.

ACKNOWLEDGEMENTS

EILEEN'S

I would like to thank my husband John, daughters Marcia and Kim for their love and support.

I'm grateful to my parents, siblings, John's father and sister for their patience and understanding over the course of our growing years.

I owe my education and training to the Early Intervention Program.

To the Early Intervention moms—Maggie, Karen, and Connie—thank you for your guidance, experience, and acceptance.

I appreciate the help of the many teachers, church members, and community individuals too numerous to name.

A huge thanks to Dr. Robert Nickel, Ginger Nickel, and Elizabeth King, for all of their encouragement throughout the many years. Without their assistance, this book would not be published.

I would like to express my deep appreciation to Jessie Clark for all of her writing skills to make this book a reality. Thank you for your time and sacrifice.

Finally, to my Lord who deserves all of the credit and the glory.

KIM'S

To God, who has made me unique.

My Early Intervention friends—Dannielle, Alicia, and Justin.

Dad, Mom, Marcia, and Louie.

Papa, Grandma, and Grandpa.

Marcia Miller and Tim Hughes, thank you for saving the book from numerous computer crashes. Your tech-support and graphics assistance have made all of the writing and artwork possible.

The neighbors and teachers for their support.

A special thanks to the Easter possum who served faithfully until his retirement.

CONTENTS

LIST OF PICTURES

FOREWORD

The behavior of children with autism often presents major challenges for their parents, sisters and brothers, aunts and uncles, grandparents, neighbors, and teachers. A number of books have been written about children with autism that describe in detail their insistence on routines, marked sensitivity to sounds and other stimuli, solitary play, tantrums, difficulty with transitions and delay in communication skills. This unique book brings these issues to life through the very personal story of a young woman with autism, her family, and their journey from her birth through high school.

I first met Kim, her mother Eileen, her father John, and her sister Marcia when Kim was 7 years old. I am a developmental pediatrician and was making a videotape entitled *Listening to Families*. This video was one of several resource materials that we created for use in health education programs to highlight the needs of families of children with disabilities and chronic conditions like autism. Eileen was very eloquent and passionate in describing her family's struggles as well as the services and individuals who had been helpful to them.

After the video session, Eileen continued to send me information about the challenges that she and her family faced, and she also introduced me to Kim's artwork. In fact, I have been blessed to share in this family's story through regular updates from Eileen and one of Kim's teachers. I have been struck by the struggles, the solutions, and the wisdom in this family's story as illustrated in Kim's artwork.

I have encouraged Eileen to write this book and share it with you. This family's journey has been both remarkable and routine, from chronic "battle fatigue" when Kim was an infant and toddler to an anxiety-riddled transition to middle school when Kim drew herself as the sole survivor and voted everyone else off the island (out of school). Both Eileen and Kim are remarkable people—Eileen for her untiring advocacy on behalf of her daughter and Kim for sharing her view of the world with us through her art.

This is a wonderful book and I recommend it highly to anyone who wants to learn about the day-to-day reality of growing up with autism. Parents should take great encouragement from Kim's progress from a non-verbal preschooler to a high school graduate and now community college student. Finally, parents should also take special note of both Eileen's support for Kim and her advocacy. It is your advocacy for your child, like Eileen's for Kim, which will be the critical element in their success.

Dr. Robert Nickel,
Developmental Pediatrician, Professor of Pediatrics,
Child Development and Rehabilitation Center and Department of Pediatrics,
Oregon Health & Science University.

INTRODUCTION

One afternoon over a decade ago, after giving a television interview for an upcoming charity event, I found a moment to strike up a conversation with the producer of the commercial. My daughter Kim, who was kindergarten age at the time, had an opportunity to show her artwork at a local annual Art Guild show. It was quite a prestigious event, especially for a person so young. The producer was very impressed by many of the stories I had about all of the wonderful drawings by my special artist who had autism. Several of the sketches were rendered at an impressive speed of a minute or less. I had to laugh as I relayed the account of a newspaper photographer who had come to take her picture. After several snaps of the camera, he asked me if I could convey to Kim that she needed to slow down. He told me that she was finishing the sketch faster than he could click the shutter!

I continued talking with the producer, telling him about her autism and the symptoms of the disability that seemed to suppress her ability to speak, until she learned to use sign language. Finally, I proudly announced that, in the course of time and with intense work, she had begun to speak. Like flipping a switch, suddenly he lost interest. I tried to explain that there was still valuable information to be gained from those pictures that she drew. He was no longer fascinated after he learned that she could talk. What he failed to understand was that just because someone is able to verbalize, it doesn't mean that they have the ability to communicate.

Kim's artwork has shown us so much more than we could ever have read in books about autism. She found her voice with paper and pen and then, like any verbal child, she used this language to convey her wants,

needs, and dreams. By doing so, she changed the course of her life as well as the perceptions of those around her. Over the years I have encouraged people to listen to her work, to see what she has to say.

This book is about a child who reached out past the confines of her disability to reveal her feelings and her thought processes through the medium of art.

She truly is *The Girl Who Spoke with Pictures.*

Making her Mark

GRANDPA'S PEN

Because my youngest daughter, Kim, had a horrible habit of grabbing anything that would make a mark and dashing for the walls, we were ever vigilant of items on the floor. If we found a pen or crayon on the carpet, it was immediately placed on the bookcase or mantle far from her reach. In the event that she did find something, we wrestled it from her as she screeched and swiped wildly at the wall, trying desperately to make her mark. She always took it quite personally and made us pay with mournful behavior for the next few hours.

At the age of three, the only time in which she was allowed to hold a pen was when her 80-year-old grandpa came to visit. He always had a pen for her in the pocket of his tan khaki shirt. He lived only two houses down from us, and it was his routine to come to visit Kim, and her older sister Marcia, every afternoon. Kim would meet him at the door, escort him to a chair, and crawl into his lap in search of the ballpoint pen. He let her hold it. She clicked it a couple of times, and then put it back in its place. It was as though she knew he was grandpa from this comforting ritual, and after the little routine she was aware that there were treats waiting in his pockets.

Sometimes the three of us walked to his house for an ice cream treat. His table was covered with a vinyl tablecloth and plastic mats. He was a methodical man and kept all of his correspondence and writing materials at hand right there where he spent most of his time. He also kept his prescription medications, his to-do lists, and his receipts there. It was my habit

to take away all of the medication bottles and writing implements before Kim climbed up to the table.

One particular day, I was a little slow at removing these things. Of course, Kim had her hands on his pens immediately. I was just about to commandeer them when he reassured me that there was nothing there that she could ruin. Several note pads and pieces of paper, which he used for writing lists, lay on the table. He let her have some of these scraps of paper as he scooped the ice cream.

When it was time to go and I began to tidy up the spot where Marcia and Kim had made marks on the papers, I noticed that Kim's slip of paper was covered with what looked like Morse code. Over and over she'd marked dot, dot, and dash…two dots directly above a dash. A deliberate dash, straight and even.

I took the slip home and pondered over it. Did it mean something, or was I just trying to read something into it? It seemed too deliberate to be an accident, but what was she trying to say?

The next day we went again to grandpa's for ice cream. Both girls adored their grandpa, but especially Kim. Nothing ever changed at his house. Again, she was indulged in her rare opportunity to make her marks.

I watched over her to gain some clue as to what she was doing, but, when she sensed she was being observed, she shyly scribbled out the marks. I reassured her and asked, "Is it a face?"

"A face."

"It's okay to make a face. Look! Mom make a face." I turned over the receipt and made dots and a dash just like she had done. Then I made a circle around them.

"A face, a face, a face…" She kept repeating it over and over.

"Draw a face, Kim," I told her. Instead, she drew a figure starting with what appeared to be a body, to which she added a leg, an arm, and even a hand. Then it got to be too much for her, and she started to scribble all over it.

I didn't understand why she didn't want me to see; most children are proud of their artwork.

Maybe she thought making marks on anything was forbidden. Although we had tried to turn her interest away from writing on walls to writing on paper, by the time we introduced the paper she was always distracted or too upset by our altering her plans to draw on it.

Maybe she had made an error. She is an incredible perfectionist and, if she felt she'd made a mistake, she wouldn't want anyone to see it. Whatever the reason, she didn't like anyone watching over her shoulder while she drew.

Unfortunately the original dot dash pattern on the receipt was tossed away. This drawing (Picture 1.1) was one of the first that we kept. One large face dominates the page while there are several disjointed dots and dashes. Interestingly, she created an eyeball by circling the small dot in the center encapsulating what appears to be an eyebrow. There are purposeful marks near the chin area. They could be the beginning of other faces or a compulsive act of performing the same task over and over. However, without being able to consult the artist at that time, it would be impossible to tell.

Picture 1.1 One of the first ($3\frac{1}{2}$ yrs)

At this point, we couldn't possibly realize the incredible event that was happening before us. We were witnessing the beginning of something new and exciting, something that would change the direction of all of our lives, especially for my three-year-old child.

IN THE BEGINNING

Kim's was not a typical onset of autism; her early symptoms were much like colic. The sleep pattern she established from infancy was screaming inconsolably for nearly 24 hours a day for the first five days of the week and then sleeping for six hours at a stretch for the last two days. She screeched constantly, seemingly terrified of her surroundings. The telltale autism indicators of extreme sensitivity to touch and sound, and the inability to adapt to any changes in her environment were present. She had a troublesome bump on her head as the result of the birth, which may have explained the seizures that she experienced every time she nursed, or focused her attention. Her body stiffened, her gaze fixed, she stopped whatever she was doing. Even though I poked her body with my finger, nothing could rouse her. It was as though she momentarily checked out of her body. My husband, John, and I were truly perplexed at her behavior, which was very different from that of her two-year-old sister, Marcia.

I continually took her to the pediatrician.

As Kim approached nine months of age, her continual screaming began very gradually to subside. Before this time, because she had always had her head tucked tightly into my shoulder, no one had had much chance to get a really good look at her. She remained absolutely terrified of John, and her rejection of her own father hurt his feelings more each time.

Kim rarely cooed or smiled and she became easily agitated whenever I tried to play with her or even make eye contact. I noticed that she didn't like to clap her hands or interact. Again, her behavior at this age was unlike Marcia's, who was very social and always pleased to gain a reaction from us. After a while, I just left Kim to entertain herself. She seemed to prefer it that way.

Young children usually like to explore their environment, reaching out, curious of their new world, but Kim as a toddler would rather sit and stare

at a baby toy rattle made up of concentric circles. At this time, her fear of other people's faces intensified, making life difficult out in public. When visitors dropped by our house, she was emotionally devastated, screaming and hiding until they were gone. She crawled away from the front door, keeping her face hidden, as though she were under violent attack. It was disturbing to her to think that people might pop in and out of our home at any given moment.

She learned to roll over and walk, and she developed fine motor skills, all at the appropriate ages. There were, however, some strange twists to the way she used her skills. She crawled up steps just like any other child but became paralyzed with fear trying to get down. Our deck was two small steps high. She would turn her body around to cautiously back down, but she began to panic when her foot did not touch the lower step. After a lack of success in verbally encouraging her to step down, I attempted to press her foot down on the step. When her terror turned to hysteria, I just gave in and picked her up. I also noticed that she treated a crack in the sidewalk as she would a step, only without the hysteria. She got down on all fours and crawled across the crack backwards, just as if she were backing down stairs.

Once she wanted, for some reason, to fit four small plastic bunnies onto a little metal plate. Try as she might, she could never line up all four side-by-side. They would fit only if one were turned perpendicular to the others. This sent her into a tantrum. Her sense of order outrageously wounded, she tried and tried to make them all conform, but the offending rabbit always fell off. There seemed no way to comfort her. No way to explain that they just couldn't fit. I showed her several times, and at last she just lashed out, hit the plate, and sent everything flying. She was broken-hearted that I couldn't help. I often wondered why it was so terribly important to her.

Sometimes she stole her way to the refrigerator. I would find her staring at an egg in her flattened palm held at eye level. She would pivot her wrist as the egg fell to the floor with the always sickening splat. It was an emotionless, apparently senseless exercise performed again and again.

The most peculiar thing that she did, every night for weeks after Marcia drifted off to sleep, was to straddle her sister's chest with her legs and, while sitting there, explore Marcia's eyes, lifting her eyelids, peering closely at the sleeping eyeball. After a while she'd move on to the mouth,

examining the crevice with her fingers. It was a wonder that Marcia never woke up during this process. Finally, she'd stick her fingers up Marcia's nose, very gently probing, as if in search of an answer to an unknown question.

As I watched very quietly from the doorway, a cold shudder would come over me. What was she doing? Didn't she know who we were? What we were? Night after night, she searched for her own clues as I stood there trying to come up with a reasonable explanation for these inspections.

When Kim was almost two, she began to shrink away from me even more as I tried to play a pat-a-cake clapping game with her. Marcia, at this age, had gazed into our eyes and found incredible enjoyment at our expressions. We had spent large amounts of time playing interacting games with her. Kim, however, seemed upset by looking in the direction of our faces and was even more agitated when we clapped her hands together.

She continued to avoid eye contact and, when I entered the room, she didn't even glance in my direction, let alone hold out her arms to be picked up, as Marcia had done at that age. Kim didn't respond to her name being called, although, if the refrigerator quietly started to run, she whipped her head around toward the noise. We were concerned that she was deaf; however, her hearing seemed to be selective. We were in search of answers, constantly taking her to different doctors. After being prescribed countless antibiotics and decongestants for supposed ear infections, and after continual "well baby" visits, we were no closer to an explanation. None of the physicians who examined Kim could find anything wrong, or even appear to recognize the elementary signs of autism.

She began to shy away from our touch, immediately vacating our laps to move farther away from our reach. When there was a center of activity in the room, she grew more evasive, preferring to stay on the outer edge of the space. There was never a wistfulness in her eye or facial expression that showed she would like to join in; as a matter of fact, she acted as though we weren't there at all. She never initiated sounds to try to elicit anyone's attention, or used a fixed gaze to indicate any wants or needs. One day she was picking daisies and, as I got closer, she moved away. Again I moved closer, and she moved farther away. I captured it in a photograph showing her actually leaning away from the camera. Eventually, she turned her back on me. She became more aloof as the weeks passed. Her lack of attachment

to us or to any kind of object, made it very difficult to keep her from escaping or running away. She related to objects and was attracted to their appearance but didn't cling to anything for comfort.

She postured her hands and grimaced with her mouth whenever she met an unfamiliar child, and I guessed it to be her way of saying "hello." The posturing of her hands is very difficult to describe. Essentially, posturing is a way of holding the body in an unnatural position. When I say she "postured her hands," it might mean that the wrists were bent inward with her fingers rigidly splayed out. It might mean that her hands were held up in front of her body with one tensed palm up at the wrist, and the other palm down. It was not so much the position of the hands, though: it was the awkward manner of their position and movement. When she met an unaquainted child, she would jut out her jaw and bite the heel of her hand as she held her hands bent back at the wrists, palms upward, fingers stiffly curled.

All of this unusual behavior was puzzling, because she was being raised in a very loving and nurturing home. My husband, John, and I could come up with no explanation for her actions. Marcia and Kim were being brought up in the same environment. Why was Kim so agitated, and what triggered the problems that she had? Her behavior made it more difficult to carry on the normal activities of everyday life, but for the most part we made it all work.

However, when she did not initiate sounds or begin to speak by the age of two and a half, we took her to an audiologist who found no physical problem but confirmed a development issue. She had virtually no system of communication other than throwing tantrums when she was frustrated. Many individuals who lack speech compensate by pointing or at least using their line of sight to indicate desires and necessities, but she did neither. She had 35 of 50 symptoms of classic autism as well as seizures when she became stiff and stared off into space for more than a minute. Some of her symptoms have been and are hypersensitive hearing and tactile responses, sensitivity to textures of foods, self-abusive behaviors, hand flapping, tiptoe walking and circling for long periods of time. "Flapping," is difficult to describe accurately. It's another of those manner-isms that, once seen, you'll always recognize, even if the actual movements aren't the same. Kim "flapped" by holding her upper arms close to her

body, lifting her forearms to about waist level and then flapping her hands up and down by rapidly pivoting her wrists. There was one stereotypical characteristic that was very puzzling. Oftentimes I found her holding strands of hair in her hand, gazing toward a light source and waving the sandy colored locks in front of her face. This was a self-stimulating or "stimming" behavior that seemed to create some type of exhilaration within her.

The audiologist referred us to the Early Intervention Program. It is a nationwide program in the United States that determines eligibility for services, refers children to proper agencies for diagnoses, and educates children with disabilities. After several observations of her behavior in different environments and the appropriately administered tests for autism (Psycoeducational Profile (PEP)) by a licensed specialist, she received the diagnosis of autism on her third birthday.

It was about six months later when Kim began to draw her faces.

THE ARTIST

Weeks went by, and still Kim drew faces. Sometimes they had more dots or freckles. She was more than likely perseverating (performing the same task over and over at an unusual rate [see pp.51–56]). I wondered if she would stay with drawing the heads and not move on to anything else, but after about six weeks I noticed a small line drawn under the chin of each expressionless, disembodied face.

One day, I heard her say "pants" as she began to sketch legs. They weren't just stick figures or lines, but jagged and wide. It was the same method for the arms. She became obsessed. The limbs in the pictures grew tremendously out of proportion. Little did I understand that, all the while, she was processing and analyzing the human body. In this particular sketch (Picture 1.2), there are seven human figures in varying shapes and sizes. Great care was given to the feet, a special detailing added to three of them. At the upper left portion, it appears she was in the process of drawing one more figure.

Picture 1.2 Pants ($3\frac{1}{2}$ yrs)

As any artist does, Kim struggled with her art. One evening, she approached me for some help. I was so happy that she felt she could turn to me! She handed me her paper and pen (never pencil) and said, "Shaw noi."

"Draw noise?" I asked. That was met with a definite negative response. She tried again with the same words. I asked her again, was it "noise"? She threw herself down screeching. I quickly drew a drum with sticks to illustrate noise. She vehemently grabbed the paper and tore it to shreds. John tried to offer his assistance. She pulled her fragile self together and made her request once more. He was as puzzled as I was. Again, she was on the rug, throwing tantrums and fuming for over two hours. We collectively wondered if this drawing thing was good for her.

That was not the only time Kim became frustrated. She was becoming more and more of a perfectionist, or rigid, about her drawing. It was as though there were unwritten rules in her mind. She was very careful to make all the lines meet. If she happened to pull the pen up from the line too late, there would be a small tail on the line as they overlapped, which caused tantrums. Picture 1.3 is an example of the pen overlapping and causing unwanted marks on the end of a line. The figures are positioned with particular attention regarding their placement on the page. This is in contrast to her previous sketches where the placement of figures appeared to be chaotic. As a very young child, she was continually striving to gain control over her medium.

Picture 1.3 Proportion ($3\frac{1}{2}$ yrs)

We tried to introduce a pencil with an eraser, but to no avail; she wanted a pen. Pencil lines never quite erased completely to her satisfaction. There was still an indentation left in the paper where the pencil mark had been. This was a stage we learned to bear.

She drew as easily in one style or font as another. There seemed to be no boundaries in her thought or expression. Characters slowly developed from cartoons and movies. Many drawings involved mysterious objects organized in groups. Somehow they were significant for her to record. I then noticed she was drawing arms behind the head, hands in front of the body, layering objects and implying depth. The drawing of the smiling flower face (Picture 1.4) has the appearance of being layered. After sketching the front petals, she added the details behind. The bee has curved stripes on its body suggesting the roundness of its torso. There were no unwanted tails on the ends of her lines, which indicates to us how meticulously each character was made.

Picture 1.4 Beginning 3D (4 yrs)

It was almost as fascinating to watch her draw as it was to enjoy her finished product. Her favorite position in which to draw was outstretched on the carpet. Periodically, she'd jump up momentarily to express her joy while bouncing and flapping intensely as she hyperventilated. After conveying the happiness she felt, she dropped back down almost in one motion, lying stretched out on her stomach once more to her prone position on the rug. She usually talked to herself in an unknown dialect as she made her faces. She started with a small detail or insignificant part of the picture and added on from there. Several times per page, she interrupted herself with her little joyful ritual of jumping up and flapping.

Her body moved all around the paper, which lay fixed in the same spot. She could draw from all angles of the page with the perspective of the picture staying the same. At times she used her index finger on her left hand to guide with invisible lines the pen held in her right hand. It was intriguing to watch the picture develop almost like a magic drawing board.

With the exception of "drawing noise," Kim rarely approached us with her drawings even for affirmation or praise. She didn't request ideas for something to draw. Her art flowed steadily from her as easily as the air she breathed.

Because she drew more when she was excited or over-stimulated, by the end of the night/morning, there were sometimes more than 50 pages scattered all over the floor. John was tired of the constant disorder in the house. He requested to at least be able to cross the living-room in the morning without paper crunching under his feet.

There were many times Kim stayed up all night and the volume of paper grew greater still. As I picked up and stacked the papers, I noticed that the subject didn't vary much from page to page. I saved a couple of papers every now and then and discarded all the rest. Some drawings were of strange objects. I asked Kim about them, but received no answer. The language just wasn't there.

As I went through my nightly ritual of straightening up, something in her pictures attracted my attention. It was as though she was trying to show that she understood that there was depth and mass and dimension to objects. My belief is that, judging by her early drawings, Kim's depth perception was extremely acute and, therefore, crawling down steps as a baby was very scary. That is why she got down on her hands and knees to pass

over a crack in the sidewalk. Imagine how frightening the world would look through her eyes.

Although her test results in development were low, the preschool teacher and Early Intervention staff could gauge her intelligence by what she revealed to them on paper. The teachers didn't really need the tests that they were required in their profession to administer. They looked past the examination results and measured her development by the information provided in her art. We were very fortunate that Kim had this gift; she had the opportunity to express and share her view of the world from inside.

We enjoyed watching her body of artwork as it evolved over the course of weeks and then months. Smiles started to appear on the faces, different animals portrayed human characteristics. There were small details that could easily be overlooked if you weren't familiar with her style.

I've often pored over Kim's early sketches, looking at them through the eyes of hindsight. There was a style, beauty, and grace, as well as movement, beyond what words could really say. She has always had a keen sense of composition and great awareness of space. If she had a small scrap of paper, she drew accordingly. When she was provided with a very large

Picture 1.5 Running (5 yrs)

poster board-sized sheet of paper, she was able to sketch her subjects larger and in proportion. She never paused or was intimidated by the size of any paper or subject matter. At times her subjects were rendered as though they continued onto another page. Picture 1.5 illustrates her ability to convey motion or action. Kim understood that the placement of her subject regarding the composition on a page could indicate the direction of movement. The girl is about to run off the frame of the page, her hair streaming behind her. The muffin appears to be tucked behind some other food on the tray, giving it a three-dimensional quality.

Everything Kim could lay her hands on was a potential canvas. Whatever the medium, whether it was beads, decorative frosting, or even seashells, she turned everything into art.

Chapter 2

The Effects of Autism

STIMULATION

In the beginning of her life, Kim had adverse reactions to different situations, different environments with no apparent cause, or so it seemed. She screamed whenever the wind blew, when someone entered the room, whenever we went anywhere. What we did not realize was that by constantly changing the context of what she knew, she had to continually adjust to a new situation. Most children her age didn't notice or didn't care as people walked in and out of a room. Typical infants do not react or even wake up when being passed from one person to another to be held and, even if they do, they are soon pacified by a familiar face. The babies whom I knew seemed unconcerned where they were going or who might come and go in their lives as long as their physical needs were met. Kim knew what our home was like, the furnishings, the people, the animals, the smell. It was a somewhat predictable environment. By inviting someone into our home, moving one piece of furniture, or introducing a new toy, for her, everything had changed, it *felt* different.

Although Kim, at two years old, steadily grew increasingly indifferent to anyone in her vicinity, she could absorb the energy, the stimulation in the room. Whether it was the number of people in one given area or the emotion they exuded, she felt all of it, even if none of the people's attention and none of their energy were directed at her.

Environment has everything to do with an autistic individual's context, or perhaps it would be better to say that a person with autism is context-specific. Certain events should occur at precise times or specific

people should be involved in particular activities. When events don't happen in the order an autistic person is anticipating, and when people associated with a role at a particular occasion are not present as expected, it can cause a heightened sense of excitement or possibly disorientation. The feeling of being confused or of events happening out of order—out of control—can increase stimulation to the point that an individual becomes hyperactive. Sometimes when the preschool teacher was ill and required a substitute, it threw Kim's whole day into a tailspin of chaos.

When Kim was a small toddler, she circled the floor by galloping on her tiptoes while looking out of the periphery of her eyes. She was in constant motion, unable to keep her body still, often leaping off the couch. We spaced our furniture in such a way that it would discourage her from trying to leap from place to place.

Too many events in her schedule could stimulate her so much that she could not settle down to go to sleep, or overwhelm her to the point that she could not control the energy that coursed through her body. For my daughter, high stimulation manifested itself in tendencies to flap her hands, kick her feet, and thrash her head around while in a sitting position. In the later years of high school, she developed headaches.

Factors that affect stimulation include the number of people gathered in relation to the size of a room, or the number of products on the shelf of a store (visual), the number of times a person is touched in one day (tactile), the noise level (auditory), and/or unexpected or unscheduled events (time and space).

All of the stimulation gathered through an individual's senses can accumulate until an autistic person feels an overload. The enhanced sensitivity of this condition makes it very difficult for an individual to sort out what sensory input is important and what can be ignored. During this huge task, an autistic person is expected to carry on with the chores and duties that everyone has to do regarding life skills or work. Somehow typical non-autistic people have natural built-in screens that filter out and disregard the previous stimulus that they have gathered through their senses.

VISUAL ACUITY

Even though Kim had a somewhat "spacey" look to her demeanor, she was taking all of the details of her environment in. However, her emotionless round face did not light up with joy from recognition of a familiar person or of a beloved toy. We could not draw any inference regarding her body language. Her demeanor was flat and mechanical. She didn't give any cues we could use to pinpoint an unexpressed want or need. It wasn't until she began to draw images of her daily life that we realized how much of the world was permeating her outer shell. From the information we found in her drawings, we could tell that she noticed what was reflected in a mirror across the room. In Picture 2.1, the round object on the wall with a pumpkin decoration on the top is a mirror that shows her double door, the smiling dog clock, and a tube of makeup, which was indeed what would have been reflected when viewing the mirror from her bed.

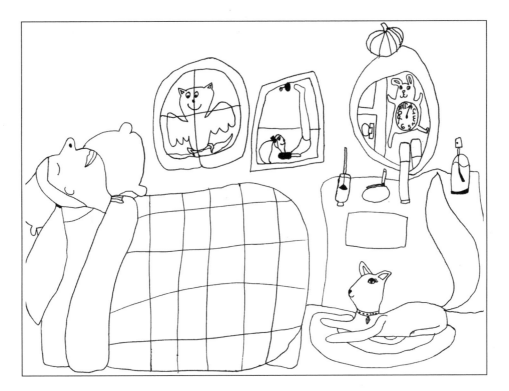

Picture 2.1 Reflection (6 yrs)

There was always a little surprise when reviewing Kim's artwork. Not only was it a delight to see her enjoying drawing a picture of herself building a snowman, but to see that she had added the true-to-life detail of the broken button on her jacket. Many drawings revealed the depth of stairs or furniture as well as the many facets of gems. Incredibly, at the age of five and a half, her art showed the crevices of flowers and garden plants with simple lines. Six months later, she was showing that she understood depth in a three-dimensional way by layering objects in front of or behind each other.

When Kim had too much stimulation, she pressed the backs of her hands into her eyes or filtered the scene by squinting. The purpose of squinting was to limit the painful visual overload and not was a reflex action. The excitement appeared to magnify the amount of visual information available, and squinting limited the amount that she could take in at one time. As the exhilaration for the moment began to overtake her, she would look out of the periphery of her eyes and try with great difficulty to navigate a room or outdoor terrain.

When I began to understand the importance of limiting her exposure to a visually charged atmosphere, I adjusted my actions by no longer taking her with me on all of my shopping errands. I was now able to recognize situations that could cause Kim discomfort, such as stores that were stocked with items from floor to ceiling, preschool rooms over-decorated with patterns and colors, designs in flooring that terrified her so. I became more conscious of the blinking lights on store displays, the large decorative tube of water bubbles at a local restaurant, flashing rotating mirrors on signs. During the holidays, we were careful not to get carried away with sparkling, shiny or incredibly ornate decorations. By being aware of this sensory overload, we could bring down the heightened sense of stimulation that exacerbated the symptoms of her autism.

EXTREME TACTILE RESPONSE

From the time that we are young, we are taught how important the human touch is to give comfort, to show love and affection, or even to communicate. There are studies about children who have not had the nurturing

touch of another human being, and the kind of psychological effects that can be brought on by the suppression of physical contact as well as neglect.

As an infant and toddler, Kim arched her back flailing away from me, stiff and wailing. She did not gain any kind of comfort from my touch or my presence. I figured that it would get better with time or familiarity.

Touching her shoulder or even coming near her could also add to this puzzling level of excitement. Oftentimes she cried out and tilted her body away from us when we came near. One day as she was quietly and calmly playing, I put my hand on her back. All of a sudden her heart rate shot up alarmingly and I could see her heart pounding in her chest. It disturbed me that I had had such an effect on her physical being. I didn't realize that just our gentle caress or mere physical presence could alter her calm relaxed state to the point of a distressed heightened state of awareness.

The act of touching could lead to other symptoms of an overexcited sense of stimulation. In later years, when I asked her why she avoided our touch, she told me that it was physically painful. Ironically, she could take a needle or pin and puncture her skin many times, watching the blood come to the surface and asking (in sign) "happened?" What was the difference? The pressure on the skin? Did it matter who was causing the pain? Was she so intrigued by the blood that she couldn't pay attention to the signal in her mind telling her that she was causing pain? It was evident that there was a problem in her body's ability to send and receive proper signals. It was either under-sensitive or over-sensitive.

When Kim's cousins came to visit for a few days, they played games like tag and wrestling. She developed a rash from all of the excited activity, the inadvertent touching or closeness to others. Although she enjoyed her family, she shrank back from our presence and screeched whenever we tried to sit by her. Whenever she showed outward signs of being over-whelmed, I advised friends and family to limit their amount of touch. Of course this sounded absolutely ridiculous to them, but they kindly refrained from reaching out to Kim. After witnessing the fact by moderat-ing their touch, they understood that she needed to initiate reaching out to play. She had a more composed relaxed demeanor, could focus better and was a far more willing participant in activities than when they grabbed or held her hand. She often elected to come nearer and actually sit quietly next to us. It was always a pleasant surprise when she did so, but we could

only exchange happy looks with each other because, if we outwardly expressed our pleasure in any way, Kim would take in the excitement, run off and the moment would be over.

This depiction (Picture 2.2) of Kim willingly and calmly walking hand-in-hand with me is one of the most endearing (to me) of her collection. It appeared at a time when she writhed, apparently in pain, at my touch.

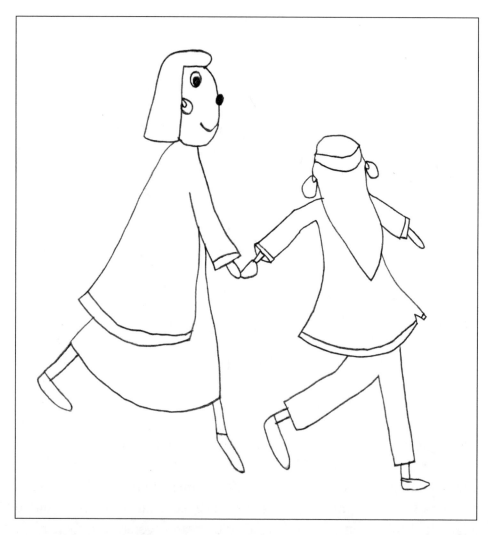

Picture 2.2 You and me (5 yrs)

Because it bothered her to hold hands, we did so only when absolutely necessary for safety in parking lots or crowds. I purchased a handleash. Now, the thought of such a thing is abhorrent to some people; I used to be one of them. I thought that using such a device was demeaning to the child, and that it was a mark of sheer laziness on the part of the parent.

It took about three weeks to get Kim accustomed to the soft cloth handcuff that was connected by a plastic accordion cord. Everyday I took her over to the deserted school across the street and placed the handcuff on her tiny wrist. She tried rubbing it on the ground, a tree, anything to get it off. She screeched so loudly and frantically that the neighbors came out of their homes to see what was wrong. After a while, they only watched through their windows, undoubtedly wondering why in the world I was doing this to my child.

She had no instinct to stay with me; she drifted to whatever caught her eye. She never looked back to see where I might be and took off running if she sensed I was anywhere nearby. What she didn't understand was that this cord between us meant more freedom. It was a means by which she could explore her environment without the painful grip or closeness of another person. As soon as she caught onto the fact that the cuff was not meant for punishment, she brought it to me as a ritual for going out. We used it so much that it wore out, and we had to purchase another. Oddly enough, though, the handcuffs device was never represented in her drawings.

After we were finished with the handcuffs, Kim still did not possess an instinct to move with me. Typical children learn a sort of "flocking" instinct. They aren't really taught this; it seems to come from osmosis or reading body language. More than likely, it is the result of connection and attachment to the adult. Incredibly, small children learn to change direction in conjunction with a grown-up. Whatever the case, Kim just didn't get it. We crashed into one another if I changed my direction or stopped. We finally plotted a system whereby, if I turned, I pointed a finger inconspicuously to where I was going. Eventually, by the time she was in seventh grade, she began to sense where we were going.

It is noteworthy that, even though Kim did not like games involving clapping, holding hands or hugging, she never reflected the tactile aversion in her drawings. Because it is difficult nowadays for people to

show platonic relationships without being scrutinized suspiciously for their motivations, most people in our culture will congratulate a job well done with a pat on the back or a "high-five" clapping of hands. This was a terrifying thought for Kim. When I explained this on different occasions to church people, school staff, and others, they consulted her on ways they could develop that would be appropriate to express their congratulations. She chose to lightly tap knuckles of closed fists. She could be included with everyone else with some respect as to her special needs. Sketches of Kim embracing her puppy, holding my hand, being part of a group were the scenes that filled her inner life.

HYPERSENSITIVE HEARING

John and I had no idea that the environment we created in our home would have such a profound effect. We figured that Kim would be like most children and acclimatize to her surroundings. She sometimes writhed in pain as she covered her ears begging, "Stop it! Stop it!" Then, if I listened hard enough, from inside my home, I could faintly hear a dog barking more than a block away. That couldn't be it, I told myself. I could not believe that such a trivial noise could be the source of her problems.

Interestingly enough, when the neighborhood was completely quiet in the early hours of the morning, Kim was better able to concentrate and learn. She learned more readily as I taught her to use sign language while we watched movies.

Because of her sensitivity to sound, we were unable to play music at home. She screamed in reaction to the sound, so it was fruitless to try to enjoy any of our records. Eventually I took the entertainment center to the upstairs attic. Music was rarely played out loud in our home because it caused so much distress.

Music has an incredible effect on those who have the ability to enjoy it, but it requires total auditory processing, which was one of Kim's greatest weaknesses. In the beginning, I believe that she heard separately all of the instruments in a musical piece. To her, it all added up to a discordant and disturbing mess of sounds.

Musical instruments have always held a charm for Kim in her art. In the playful way of a small girl's fantasy, she became obsessed with the idea of playing the flute. A teacher from school loaned an instrument to us for the summer, and I hired a girl a few years older than Kim to teach her how to play it. Unfortunately, Kim did not possess the air control it takes for such an instrument. She was still very young and just not ready. So she played the flute vicariously, through her art, to her heart's content (see Picture 2.3).

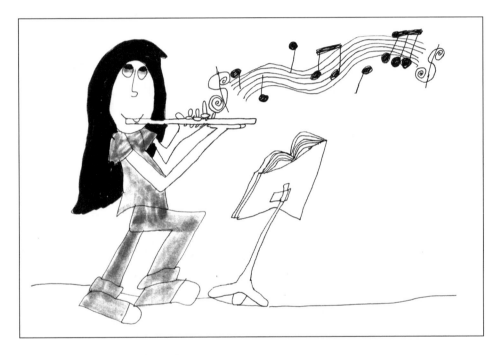

Picture 2.3 My music (8 yrs)

As I sit down each year with teachers to go over Kim's individual education plan (IEP) for the upcoming year, I look around the table. Some of them are there with eyes glazed, seemingly tempered by experience. Others are anxious, not knowing what to expect and trying to be ready for anything. And there are the few who are apathetic, apparently uncaring. I have met all these.

This is the time I pass around her drawings and suddenly, each person becomes interested and engaged. They become believers. Not only do the teachers have tangible evidence through which to view Kim's thoughts

and feelings, they can also see the intensity with which she truly experiences painful sound.

One of my favorite drawings to show is from her sixth-grade portfolio. It says it all. The sounds throughout the day at school can compound to the point that, for Kim, they are unbearable. When this drawing (Picture 2.4) is examined, it directly and distinctly communicates exactly this. There is no chance of miscommunication. There is no other way to look at this drawing and not understand that the impact of sound causes her real pain.

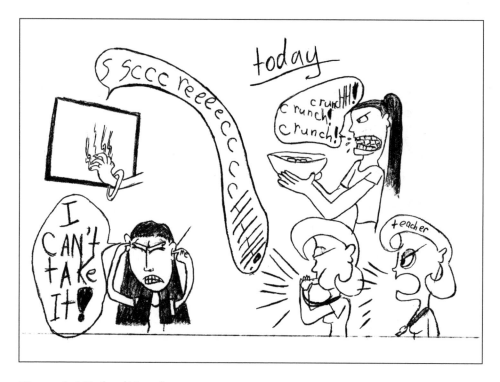

Picture 2.4 Today (12 yrs)

It took me a long time to understand, because we as humans hear all kinds of varying intensities of sound during the day that we experience and forget. Another factor in the hypersensitivity of sound is not only the level of sound but the inability to anticipate the sudden sensory input. In other words, it's a surprise. The blast of the backfire sound from an automobile, the feedback squeal of a microphone, perhaps the sound of a dish breaking on the floor or the suddenness of an unexpected sneeze, all catch many of us unaware. We experience it. We may exclaim how sudden or loud it is and

then go about our business and forget about the event. It seems that the typical child is born with the ability to screen what is important information and what is not. Because Kim has a type of virtual reality memory, the sounds are etched into the memory of the day and compound to the point that she needs a quiet time at the end of the day in which to unload and untangle her complicated mass of sounds, sights, and experiences.

One of the strategies for cutting down on her auditory hypersensitivity is to be aware and to limit the amount of sound at home. Our house is not as quiet as a morgue or library, but we as a family are aware of the effect that volume, duration and pitch of noise have on Kim. There is no way to block out every disturbing noise; however, we don't have to subject her to noise

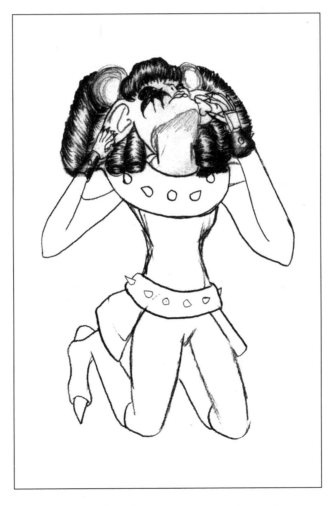

Picture 2.5 Punk rock princess in pain (16 yrs)

needlessly. When she has a particularly tough day, we are sensitive to that fact, letting her fade into a quiet room or turning down whatever noises we can control. We have purchased Bose Acoustical Noise Reduction™ headphones for her to cut down on basic auditory distractions from classmates while taking tests at school. The headphones are costly but still less expensive than hearing devices that mask sound.

Picture 2.5 is a very expressive drawing. It shows the devastating effect on Kim's sensitive auditory system. The painful sound brings her to her knees. Finally, it is a visual way to reveal to others just how she suffers from noises they may not even hear.

EBB AND FLOW

When Kim was first accepted in the Early Intervention Program, the staff advised me to write observations in a spiral notebook, to keep as a type of journal. I wasn't exactly sure at first what I was supposed to write. Mainly, the purpose of the journal was to send the information that I needed to communicate to the teachers without constantly calling a meeting. At first it was to make them aware of Kim's eating peculiarities and the kind of objects that could make her fearful, but after a while it became much, much more.

During the course of a year of writing in these notebooks, I noticed a type of pattern not only in Kim's stereotypical behaviors but also in her language and her ability to accept change. At each changing of the season, she showed signs of regression. Skills that she had developed, such as toileting, signing or speaking, became almost non-existent. She was more of a perfectionist, more demanding of the maintenance of a rigid schedule, less adaptable to any kind of physical change in her environment. Oddly enough, about two weeks after each of these seasonal regressions, they stopped as suddenly as they had begun. For some reason, she then had learning spurts in which she quickly regained all the skills she had lost and was, at least temporarily, far more pliable and teachable. The teachers and I learned to be more understanding and patient while making accommodations for her during the difficult times, and to actively anticipate the event and take advantage of the periods of time when she was more receptive to

teaching. Between the pages of the journal, I could see the ebb and flow of her autism.

I noted that as Kim's symptoms of autism became more intense, there was more depth perception and detail revealed in her drawings. Because she was so keyed up, she produced many copies of the same drawing resulting in the use of a much greater volume of paper. Several drawings were rendered over and over or the same theme repeated to the point that there could be 20–50 pages devoted to a single character performing the same task. This is known as perseveration (see pp.51–56). Pages featured the same subject in the same way for days, sometimes weeks, at a time. It was almost like looking at photocopies of the same page. The stimulation was the energy that spurred her on.

TIME AND SPACE

One of the most difficult symptoms of autism to explain to others is Kim's need to occupy a certain space for an appointed time during the day. This is not necessarily to be confused with the need for sameness, or consistency,

Picture 2.6 Untitled (5 yrs)

but with the existence of objects including her body filling an area (see Picture 2.6).

When beginning public school kindergarten, Kim had a hard time finding where she fitted in, not socially but *spatially*. Notes in the journal would come home asking me to teach Kim how to take her place to stand in line.

The interesting thing about standing in line is that the idea of children standing all in a row facing forward is puzzling through the lens of autism. If you think about it in the context of time and space, the line is constantly evolving, changing from recess to recess, from day to day, week to week. Different people stand in different positions, and it's hard for an autistic individual to get a point of reference. The remedy for the situation was to assign a child for the day or week to stand in front of Kim and teach her to line up behind this particular child. It worked beautifully when we understood that it was not a compliance problem but rather one of confusion. After she practiced the concept for a few months, she was able to line up without a peer model.

The importance of sitting in a particular spot was never more evident than when the principal of Kim's elementary school decided to change the order of seating at the tables in the cafeteria. Most children welcome a change of scenery from time to time and it really makes no difference where they are as long as they get to attend the event at hand. It had the most unsettling effect on Kim. She felt displaced, not from disappointment, not from a willful feeling, not from any emotion, but because, if this was not the place where she traditionally sat, where did her body belong? Immediately she used her pen to organize a revolt on paper (Picture 2.7). Using characters from a computer game she showed her feelings to the principal.

The words "kill" and "die" were not in Kim's everyday language and were not directed towards a person but used to reveal what she felt about the seat swapping idea. The very strong emotion that she conveyed was from frustration at not understanding the reasoning behind the change and the feeling of being disoriented. Had she been prepared for the change and assigned another seat, she would have been just fine. Again, with drawing in hand, we were able to show staff the incident. As a result, Kim received the services, accommodations, and preparation that she needed for abrupt

changes. More than 90 percent of her drawings showed content and happy relationships; thus, when this drawing popped up, we knew it was significant. As Kim needed to make the transition from elementary school to junior high, we desensitized her to the environment (sights, sounds, smells) by walking her all around the school while she made minute observations of out-of-the-way leaky faucets or obscure science models hanging in the windows. Even though one of the buildings we were touring was scheduled for demolition, she needed to identify with the site itself. It was not only important for her to take in the scenes visually but also to experience and feel what it was like to belong there spatially.

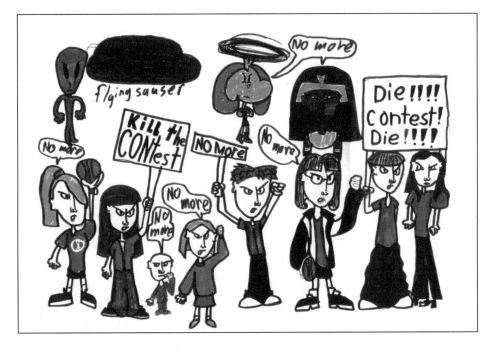

Picture 2.7 Lunchroom revolt (12 yrs)

PROCESSING INFORMATION

When I talk to others about autism, they are confused. They often remark that Kim is bright. I have to explain to them that intelligence has nothing to do with autism unless it is an accompanying disability. The ability to take in information, organize it and utilize it in a timely manner is another matter altogether. It takes time for Kim and others like her to make

decisions, to regurgitate information for tests, to apply already learned concepts to different situations for problem solving. For one thing, it requires organization of files in the brain, the ability to access those files and the reasoning to apply the correct method for problem solving. An autistic person creates a template of life experiences and media shows (i.e. TV shows, movies) to draw upon. When there is a new experience, an individual may not be able immediately to relay information in response to a simple question.

The month before Kim was to start kindergarten, she went to the local fair. She could not express whether she had experienced joy or apprehension while riding on the horse at the carousel. She sat stone-faced through the ride, not betraying any kind of emotion as she went round and round. Even though we asked her, she remained unemotional.

Picture 2.8 Merry-go-round (4 yrs)

Picture 2.8 was made almost two weeks after the event. As you can see, she enjoyed the ride. It is a prime example of how long it took her to process the event.

The game of tic-tac-toe was a very difficult concept for Kim to grasp. First of all, the construction of the grid must be correct, or the game can't be played properly, but, when trying to draw the grid (Picture 2.9), she became perseverative and ended up with too many spaces. Next, she tried to enclose the grid in a circle. I believe she saw the result of the game after it was played and tried to figure out, from that point, how to play. It was very much like when she was around 2½ years old and had attempted to fit small plastic bunnies onto a small, round tin plate. Try as she might, she could not make it work.

Picture 2.9 Tic-tac-toe (5 yrs)

Kim's visual memory is incredible in detail and nearly photographic. She could sketch a map of the United States with all the states defined in a

matter of a couple of minutes. Her habit of making the map fit into a circle was not nearly as spatially confusing to her as the tic-tac-toe game. Although not all of the states fitted, it didn't pose a problem.

It all came down to how she viewed the world, her environment. At this age, 5 years old, we could hardly predict how she might progress toward the future. If she literally saw things so differently, how could she make it work? Could we get her to adapt to how we saw objects?

Those were all good questions at that time, but she showed us the way through the years. Kim matured in her development while maintaining her creativity. With her art, she was able to work out the spatial concepts. She became more tolerant of our gentle suggestions and instruction. We gave her more time to process the information and did not insist on her compliance with our timetable or ideas. We told her that it was all right when something didn't fit and assisted her when necessary.

A new skill to challenge Kim waited on the horizon in fourth grade. Up to that point most of the questions given to her on assignment papers were framed in the same way. Now, questions posed at the end of chapters suddenly started appearing in her textbooks. Answering textbook questions was a new skill for Kim, and she balked at doing the work. Reading the words was no struggle for her; the problem involved trying to extract the answer from the text. I read the sentence aloud and then interpreted the condensed meaning for her. It was both laborious and time consuming to read each sentence and interpret it for her. Having something read to her aloud wasn't as visual as reading the text and Kim found it difficult to grasp the meaning, but, when she read it herself, it was also a slow process.

Again, the pieces were not falling into place in her mind. I had to teach her how to concentrate on looking for the emotions of characters, consequences of actions, and story themes. It was not a matter of remembering, but more of an issue of trying to match templates in the language. The answers could not be taken word-for-word from the text. The questions were worded to require the student to paraphrase and expound upon the theme of the story rather than just to regurgitate facts. The questions were more difficult for Kim because she could not understand what they were asking her to do. She read the words visually, but she didn't store the information in her mind, so she couldn't think back over what she had read to

extract the information from the story. She couldn't say if the character was mad or sad or what had happened in the story. She also couldn't recall whether a certain event had occurred in the beginning, middle, or end of the story.

Book reports and questions at the end of chapters meant that I would have to teach her all of these skills at one time. She became very frustrated because these exercises were taking such a long time, and whenever she was frustrated she would say, "I don't know. I don't know," and then I'd have to back off and give her some time. It was hard.

We taught her how to find the answers without reading the whole book or chapter over again, but each question, each chapter, each book was no easier. It was like starting all over again; even though she'd learned the skill, it didn't transfer to the next project. Kim worked twice as hard as her peers. She had to screen out distractions and to concentrate on interpreting meanings into terms she could understand.

It didn't all come together in a day, a week, or even a month, but Kim was still learning at a rapid pace. Sometimes it didn't seem like it, but she was catching up to her peers. It's just that, every time, she had to learn the information as well as the method of how to attain it.

As years passed by, I thought her ability to process new information would improve, but it didn't. Even now, she can't always access information at any given time. Whenever we take her to go shopping, it is understood that she needs extra time to make decisions.

PERSEVERATION

An individual can perseverate on a topic, character, or activity. It means to do what seems to be a meaningless task repeatedly at an unusual rate. For Kim it seemed to be a combination of compulsion and obsession.

In the kindergarten drawing of the cats and dogs (Picture 2.10), the sketch is not an example of perseveration; Kim really enjoyed drawing this theme for quite some time. There was not a real pattern to the composition, and the subjects changed. The treatment of the characters was very individual.

The sketch of the ducks swimming on the water, though, is an excellent example of perseveration (Picture 2.11). The ducks were sketched the same horizontal way on each piece of paper for more than ten pages. She stayed on this subject for almost a month.

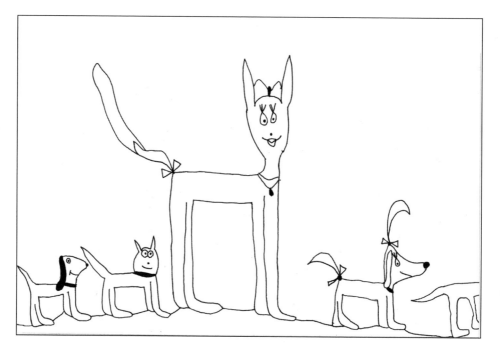

Picture 2.10 Cat and dog line (4 yrs)

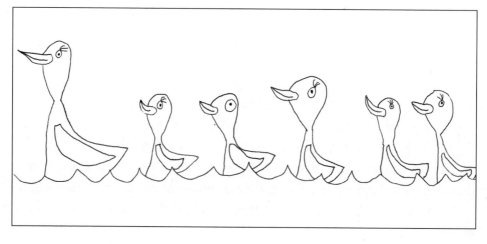

Picture 2.11 Ducks in a row (5 yrs)

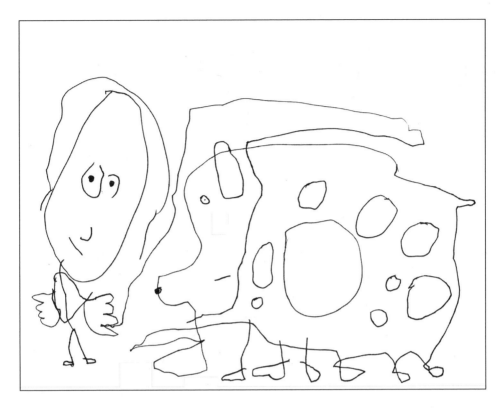

Picture 2.12 Walk a dog (4 yrs)

Another example of perseveration would be the drawing of a dog with eight legs (Picture 2.12). Although in other sketches Kim showed us that she knew that dogs have four legs, it was as though she got carried away with her art and couldn't stop. Many of her canine drawings could have from 11 up to 15 legs. All of these pages were rendered during her preschool years.

When she entered junior high school, one of her art assignments was to draw something using the concept of rhythm and repetition. Then it struck me. She had been practicing for this assignment all of her life. There is an echoed rhythm and repetition in the Picture 2.13 line drawing. It is not necessarily a perseveration, but it shows a design and an intricate pattern. Perseveration in earlier years may have led to the ability to appreciate and duplicate visual rhythm or patterns. These patterns are learned by repeating a process over and over at an unusual rate.

Picture 2.13 Self-portrait (16 yrs)

"Tesselations" and "Fractals" (see Pictures 2.14 and 2.15) are both artistic and mathematical concepts dealing with rhythm and repetition. Because many forms of art, mathematics, and science rely on patterns of repetition, it is no wonder that autistic individuals excel in these areas; it is the nature of their being. Again, these recurrent design elements are employed to achieve a pattern. What is truly interesting is that perseveration can develop into analytical thinking, something that books in the past have

stated is a difficult, if not impossible, skill for an autistic individual. By comparing differences or similarities, whether they know it or not, they are developing a very sophisticated path of thinking. Perseveration is not just a regurgitation mode of stimulation. It may seem to others that a person

Picture 2.14 Tesselations (16 yrs)

seems to be stuck in a groove doing something over and over at an uncommon rate. From my experience with Kim and what she has learned through the process of art, the possibility exists that perseveration is not a meaningless exercise.

It is my theory that the reason autistic individuals can be gifted in art, music, math, and poetry is that the visual rhythm comes so naturally, although, as a toddler, the auditory pattern was difficult for Kim to process. She never banged pots, pans, or toys to make sounds, and she couldn't demonstrate that she could pick out the beat in music by snapping her fingers or tapping her foot. She often sang a whole stanza behind, when trying to sing along with friends, and sometimes inserted more words that threw off the beat of the music.

What seemed to come naturally to us wasn't natural for Kim, but it is the nature of autism to perform something over and over. Individuals with autism are aware of patterns. Those who are more visual view, rather than hear, the repeat of a melody, a stanza, the lyric. As for mathematics, endless number sequences exist. Number sequences are found in nature, in the petals of each type of flower, the leaf patterns of each plant.

With an incredible capacity to store all this information, people with autism amaze others with their knowledge. Repetition plays a part in their need to discover the sameness, and the comfort they find in knowing that this pattern exists—that it is predictable.

Unfortunately, although life can have a rhythm, it doesn't flow at a predictable rate or a steady even pace. Life itself creates anxiety and confusion for someone whose context-based understanding of the world may depend on the consistency of the design.

Picture 2.15 Fractals (16 yrs)

Communication

If anyone were to pose the question of "What is communication?", the answer would most likely be "the transfer of ideas from one individual to another." In order for this to occur, there must be a system by which this can happen, whether it be by gestures, verbal language, drawings, or the written word. However, there are many other factors that come into play. In order for ideas to be expressed and understood by both parties, there must be a common purpose, reality/context, and perspective.

With my daughter's autism, her greatest challenge was to overcome the inability to convey her ideas, desires, and needs in order to be understood by others.

It was very important to log the bits of language and speech into the journal, so that we could reinforce her speech. For instance, when her preschool teachers took her on a special trip to a farm, they noted that she liked the sheep. After reading about this in the notebook, we would ask her an open-ended question about the animals she saw, particularly the sheep, hoping to get a response. She showed some small indication of satisfaction whenever we understood her.

She was like a child fractured into small pieces like a jigsaw puzzle. Each person who interacted with her had in their possession a different part. Piece by piece, we wrote down our observations in the journal until we had assembled a more complete representation of who she was. In order to gain the total picture of this child, a person would have to observe her at all times, in all environments and know what images, sounds, and stimulation she was exposed to, which was impossible unless someone was with

her at all times. The journal filled in many of the unknown gaps and gave us time to interpret the information she was giving us.

ECHOLALIA

The unfortunate thing about spoken language, though, is that it needs a context. Echolalia is repeating words or phrases. Kim had delayed echolalia, which meant that she could have heard the phrase she was repeating at any time over the course of her lifetime. Echolalia can be specific to the situation or it may not relate to the subject at hand at all. When she did speak, the words might have come from a movie she had seen days or even months before and, without the context of the event, movie, or commercial, the words were even harder to understand.

For example, snow is not common in our area, but one day it snowed. Marcia and I were thrilled and in a hurry to get out into it. When quickly assisting Kim in putting on her coat, I told her to put "the" hand into the sleeve of "the" coat (she didn't like the use of pronouns such as you, yours, her, hers, etc.) Somehow the pronouns were a confusing element of any sentence. As always, I explained exactly what we were doing as a way of modeling language.

"Kim needs a coat," I said. "It's cold outside. It's snowing."

"Louie?" she asked.

Louie is our dog, and I explained that Louie already had his coat on.

I didn't think another thing of our little conversation until the next time I put on her coat and she initiated the conversation.

"Coat?" she said.

"Yes. Kim needs a coat."

"Cold?"

"Yes, it's cold out."

"Snow?"

"No, I don't think it's going to snow."

"Louie?"

"No, Louie already has a coat."

This little routine went on for several months until I became very tired of it. The season was long past any chance of snow. She started once more

when I put on her coat one day, and I cut her off and impatiently repeated the whole routine—both my parts and hers.

She was so disappointed. I felt terrible. I had taken her language from her. I would never do that again. I apologized. We started over from the first word, and this time we both got into the act.

Kim's learning and using a word or phrase once did not necessarily mean that functional language would develop. She had learned such words as "Grandpa," "thank you," and "downstairs" among others, but she gave meaning to them only occasionally and didn't say them again, sometimes for years.

When she finally said a recognizable word, we were confident that a string of words or sentences would soon follow. We thought her speech would just develop in the natural progression of nouns, verbs, and adjectives to convey thoughts, but each and every word that makes up her vocabulary comes from delayed echolalia. She uses the words so seamlessly that they appear to be natural thoughts and ideas. For example, one morning she arrived at the Early Intervention preschool where she met up with a fellow classmate and said, "Nice backpack, Teddy." The teacher recorded it in her journal as spontaneous language. John and I were thrilled. At last!

Several years later, however, while watching the Disney movie, *Beethoven*, I came across a scene where some children meet on a bus and one child remarks, sarcastically, "Nice backpack, Teddy." Still, the fact is that Kim used the phrase appropriately and even in a complimentary way, so it was still a victory of sorts.

We had all been hoping that one building block of learning and language would lead to another—that the world would all make sense and come together for her. Even though she had her drawings, it couldn't fill in all of the blank spots in her communication. It seemed reasonable to think that, if she were able to accomplish one skill in language, she would master it and go on to conquer others, but with her autism this was not so.

Occasionally, she came home from preschool excited, running around in circles and giggling hysterically for sometimes over half an hour. Once, she insisted on re-enacting something on the wooden deck in the back yard. It looked like she was signing the word "angel." Then she lay down in a certain place babbling non stop, saying the same things, over and over.

Was it something funny or silly that happened at school? Did she make a friend? It was frustrating not being able to share in what she was trying to say. Her reaction to whatever had happened would inevitably remain a mystery because there was no way to frame it with a context from the many sources of stimulation that she had experienced up to that point.

BUILDING A COMMUNICATION SYSTEM

I consulted the preschool education team for advice on how to proceed with a child who didn't seem to be experiencing the same reality as the rest of the family. It was evident from Kim's unfocused manner and stress level that she was over-stimulated, and that we needed to build a framework of events in her day. By maintaining a schedule of her daily activities, from which she could make sense of the world around her, she could begin to participate in rather than just react to the flow of a huge amount of information. I had considered her craving for continuity and sameness for each hour of each day as an impediment to her ability to do anything, but the preschool staff told me that having a schedule added predictability. The schedule of hourly events had several different purposes. The familiarity of a schedule would reduce the amount of unfamiliar information she had to process all at once, so that she could focus on and learn about new things that were introduced gradually. This predictability would help tone down her frustration and tantrums by untangling confusing information and making expectations clear.

The autism specialist pointed out that Kim was a visual learner—another attribute of autism. He told me that Kim couldn't understand the concepts of "if," "when," or "maybe." For instance, if she were promised a reward, she'd have to have it immediately. Waiting was not an option because her only concept of time was the present. If the reward were postponed, the value of the motivation would be lost. It made sense that a child who gathered her information from the environment around her could only experience life moment by moment. Now it was clear that changing the objects around her did change her reality. The terms of "if," "when," or "maybe" are contingent on a person being able to form an idea

and to project a setting or situation in a future tense. Kim did not relate to past events and could not conceive of the future.

The specialist showed me several different scheduling and communication systems. One particular system involved a box divided up into different sections that utilized small objects to indicate a specific activity. Because many autistic people relate or associate certain tasks with objects rather than people, objects can indicate what task is next. He considered that this schedule would not be appropriate for Kim because she did not always operate on an object-based association. He explained that, because she was so keyed into her environment visually, she needed to utilize a schedule that could be made of photographs or simplified line drawings. The photos would have to be of one subject without a lot of background clutter or extra visual information. We started an extremely simplified schedule of only three events to show her the happenings that take place in the day. He suggested that, as she was able to accept the schedule, we should slowly and steadily add more photographs or drawings giving her more details that would make up her day.

The preschool education team's conclusion was that Kim needed to be touched as little as possible and that we should not plan too many events in her day until she could cope with them. The results of too much activity were tantrums and an inability to focus and extract the information that would allow her to interpret her environment.

It wasn't as though I showed the schedule to Kim and she could interpret what I was trying to say and be able to follow it through. It was a long process that had to be supported by family and friends to make it work. After a month of running after her with a piece of poster board with photos clipped to it, trying desperately to get her to even look at it, I began to wonder if this was going to work out for us. Her preschool teacher, Mary, suggested that I display the schedule where Kim could see it at all times, just within her range of sight. I continually placed it in whatever room she was occupying and in time she came to accept this new object.

Finally everything came together in her mind, after reviewing the schedule every day. She understood there were parts of the day: morning, afternoon, and evening. It was like dividing up time and space, a way of creating a file for her to organize information that had been so chaotic for her, but that seems to be so natural to typically developing children. We

added events that she would like to do such as going to get ice cream, to visit her grandparents on their farm, or to feed the ducks at a local pond. By clarifying and condensing her visual information, she understood exactly what event would take place in her day, so there were no surprises when the time came to move to another event or place. This cut down tremendously on her frustration and anxiety regarding new environments and the order of her day. The schedule helped her to anticipate, which was a skill that she was lacking.

We could introduce new people to her by showing her their picture and telling her about them, before she met them in person, as a way of telling her how they fitted into the continuum of her daily timeline. It was a form of communication that words could not convey. This is the way we bridged the gap.

We were now on the same page with Kim, sharing the same context and the same reality, but, as her drawings would reveal, not always the same perspective.

BUILDING BLOCKS OF LANGUAGE

Kim was far more fluent in her language of art. Although we began to use sign language to communicate, she was often stubborn at times, not wanting to sign or to speak. At one point, we resorted to a controversial method of augmented communication. A parent or assistant (facilitator) supports the wrist or arm of someone who is verbally impaired and then assists in isolating the movement of the arm placed over a communication board, or device. The non-verbal individual can then point to spell out a message or picture and thereby communicate. The controversy was over whether it was valid communication or if the facilitator was influencing the content. We tried this for a short time, but discarded the idea because of Kim's acute aversion to touch. It came down to encouraging her to use words, but, when she verbalized, it usually came out in an echolalic phrase. Whenever she did use her own words, it took a long time for her to coordinate the muscles of her mouth to form the sounds. Because she spoke very few spontaneous words, her meaning could easily be misconstrued.

She was so quiet at other times that it was almost eerie, and then, when she did speak, it was often unintelligible. When she was by herself in a room, she often spoke as she lined up objects, but her words sounded like, "Wa-sa, sa, sa. Wa-sa, sa, sa…" She would repeat the sounds with the same inflection over and over, sometimes for half an hour or so. One day, after listening to her play this way, over the course of several weeks, Mary, Kim's preschool teacher, figured it out. Kim was naming the objects in her hand, a little set of farm animals, as she lined them up. "This is a goat. This is a cow…"

As we were at the breakfast table having pancakes one morning, Kim kept saying the words "Shud-dup." Thinking she was saying "Shut-up," I told her that those are not words that we use, that it was rude. There were some words in TV shows that she was beginning to pick up and we wanted to discourage them. We tried to ignore it as she insisted on saying them over and over. This was the strategy that we, as a family, employed whenever she was on an echolalic trend. I kept repeating, "The rule is…we don't use those words." After everyone had finished breakfast and left the table, she got out of her chair and went over to the place where I was sitting. Reaching across my plate towards a container of maple syrup, she again said, "Shud-dup." I felt so deflated! Here she had been using words to communicate and I was telling her not to use those words.

It wasn't long after when she had another request. She had always had odd eating habits and I tried not to give in to the unhealthy ones such as spoonfuls of mayonnaise or pats of butter. This particular day she was asking for "Butter." Again I explained that I wasn't going to hand over some butter. "You can have it on a piece of bread or cracker," I offered. She would have none of it, but, rather than working herself up into a frustrated tantrum as was her usual way to communicate frustration, she ran to get paper and pen. In a flash she drew a peanut shape (Picture 3.1). I knew exactly what she wanted. It was a "Nutter Butter Peanut Butter™" sandwich cookie that is formed in the shape of a peanut. "Of course you can have a peanut butter cookie," I exclaimed. I was so pleased that she was able to communicate what she wanted, I would have rewarded her with ten cookies!

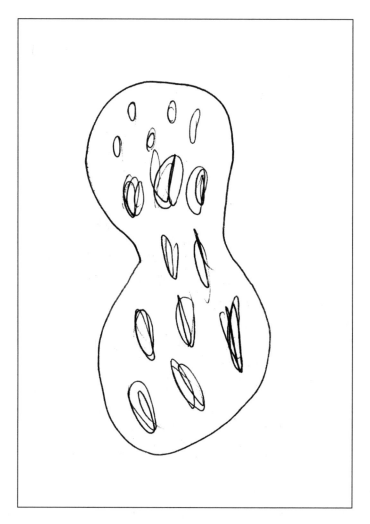

Picture 3.1 Peanut butter cookie (6 yrs)

It was evident by the time Kim was in kindergarten that she would utilize art as a form of release and communication. She discovered new concepts in her art and expanded them until she found something else that caught her attention. Her drawings were exciting to see because we gained so little information from her outward demeanor. It was another way of connecting with her; it made us feel closer.

She was, at this time, virtually non-verbal, although sometimes she gave one-word responses to questions. After we came home from our annual fishing trip at a local fish hatchery that opened their gates for a special fishing day for children with special needs, she drew Picture 3.2.

"What is this picture of?" we asked.

"Kim," she said.

I pointed to the painting of the girl who was fishing, and she indicated that it was her. So I pointed to the other girl. Both times she said "Kim."

"Kim paints a picture of Kim?" I asked.

"Yes," she said as she flapped her hands wildly while bouncing on her toes. It was a double self-portrait, which is a very advanced idea for such a young girl.

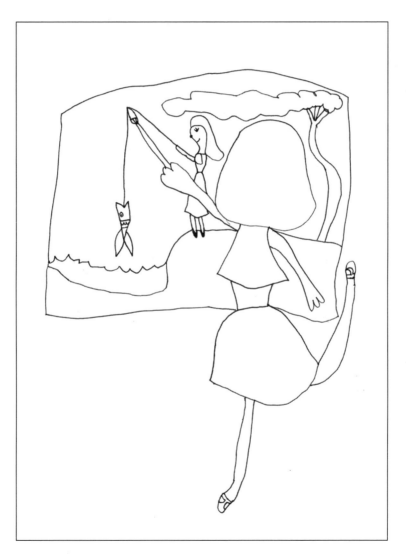

Picture 3.2 Double self-portrait (6 yrs)

Her ability to draw soon filled in a lot of the unknowns in her day. There were small details that we had overlooked in the busy times of our day that she noticed and put down on paper. She showed us information that was important to her.

UPSET

It would be any parent's nightmare to see drawings of their child frightened. Fortunately, most children at Kim's age, five years, can be interviewed to get to the root of what is bothering them. Because she was virtually non-verbal, it complicated the situation.

The drawings, up to this point, had been friendly, happy scenes of life around her. I was heartened that she apparently felt the love of a well-adjusted family, even though we weren't always completely healthy and stable.

Her schedule for the summer had been changed. Since there were no Early Intervention services for the summer, her program was extended. By documenting her regressions during the previous year and a half, we were able to show the need for some sort of structured class. The specialized preschool looked at creative ways to deliver a program to add meaning to her day. She required socialization, yet there needed to be something in a community setting that would do.

Because she really connected through her art, she was enrolled in drawing classes in a local community artists' guild. She was years younger than the minimum age but, with some of her artwork in hand, we persuaded the teacher to allow her to attend. A respite care volunteer would help Kim in moving from one task to another, as well as aid her in interpreting language.

Kim's behavior altered. I couldn't put my finger on just what it was. She had always had a disturbed sleep pattern, but this was different. She now shrieked in her sleep, as though she was experiencing a horrendous nightmare, only it didn't stop as she awakened. I tried to comfort her but she couldn't take in who I was. Kicking, and punching, she fought to get away, while calling out her name for me. My heart was broken. It became a pattern over a few weeks and then stopped as mysteriously as it began. I

didn't know if she was having a regression or if it was a change in the direction of things to come. The pattern reasserted itself in a couple of months.

I was losing a lot of sleep at this point. One day, while dozing on the couch, I became aware that she was standing beside me. She never poked me or spoke to me to wake me up. After I adjusted my eyes, she gave me the drawing of a broom, which looked evil and had its hand over what looked like Kim's mouth (Picture 3.3). I was distressed at the startled look in the eyes in the drawing, and at her hand reaching out as if in a cry for help. With the broom picture in hand, I asked her about it. She would only place her hand over her mouth.

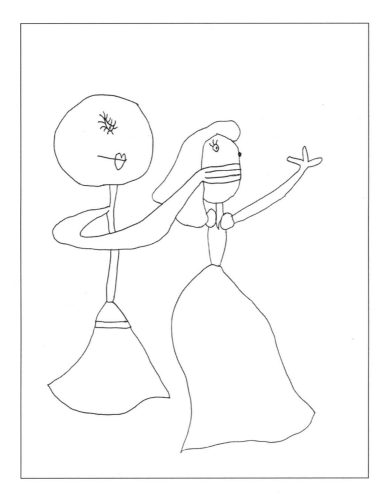

Picture 3.3 Upset (6 yrs)

We didn't know what to think. She interpreted actions differently from the way we did. The bottom line is that someone did something she didn't like. What action it could be, we didn't know. We tried for a couple of days to find out what had happened, but she just didn't possess the language that she needed to tell us.

Finally, after a few more days, I photocopied the sketch of the broom. I took Kim to our transparent glass fireplace doors, placed the copy of her broom drawing in the cold fireplace, and shut the doors. Turning to her, I asked in a low voice the name of the broom once more. She again clapped her hand over her mouth.

"It's okay. It can't hear you in there," I said. "Tell me the name."

She took quite a while to think, continually gazing toward the drawing. I reassured her again that it was alright to tell me. Finally, "It's_____," she said very quietly, still staring at the paper. The name she whispered was the name of a respite provider. Looking back, there were a few times when we used this person that she had sleep disturbances. I didn't want to jump to conclusions but, whatever may or may not have happened, it had upset her.

Because I was familiar with autism and Kim's learning style was so visual, I decided to burn the page while I had her attention. With my hands on the fireplace doors, I whispered to her that if we burned the drawing it would go away, and she wouldn't have to deal with it. She understood that I was seeking her permission, and we did it together.

I contacted the respite program with the original drawing in hand to inform them of the situation. The director totally agreed with John's and my decision to drop this person from our already short list of respite providers. Kim's behavior improved, her unusual sleeping pattern disappeared, and she was her regular self again. The pictures that shortly followed were once again of warm relationships and friendliness.

CHICKEN AND FOX

My dad and mom own a small, but productive, place just outside a sleepy little town. Shortly after Kim had started kindergarten, while we were visiting my parents on their farm, Kim showed us that she was listening, understanding, and processing information.

While chatting over a cup of coffee at the dining-room table, my father mentioned that he was having trouble with a fox nabbing his chickens. Because of the farm's size, every animal is precious, and he said he had his gun handy to take care of the problem. We went on to other news about the corn, the high price of honey, and a host of things while Kim played quietly nearby. She had a special affection for chickens because they lay eggs, which she loved. She loved them not to eat, but to hunt for and gather.

Not long after our visit, this series of drawings appeared. She drew herself hitting the road with suitcase in hand to save this chicken from grave and mortal danger (Picture 3.4). Her fowl friend would be safe if she had anything to do with it!

Then there was the fox. She made sure that he couldn't hurt the chicken by binding him to a tree—but not before her grandpa had a chance at him (Picture 3.5). Notice the bandages on his tail. She must have taken to heart what he said about dealing with that fox.

Picture 3.4 Hitting the road (6 yrs)

Picture 3.5 Fox's punishment (6 yrs)

Picture 3.6 Chicken's revenge (6 yrs)

The last drawing (Picture 3.6) shows "the chicken's revenge." That chicken was going to chase the fox away never to pick on him or his fellow chickens again.

We were very excited to see that Kim was listening even though she wasn't especially close by or attentive. She understood what was being conveyed in conversation, and she found her own solutions to the problem.

REVEALING THE DESIRES OF HER HEART

Some children let their dreams and preferences be known to everyone around them. Others drop subtle and not so subtle hints about a toy or subject of interest. By simple observation, even the most shy or quiet kids light up whenever they see something that captures their attention. With Kim, it was difficult to know because her expression did not change, nor did she verbalize her wishes. Choosing gifts for her became a near impossible task. She had an aversion to the idea of new objects in the house. Many times we completely failed to come up with one gift that we were sure would bring happiness for just a short while. We turned to the pages of her art for answers to those questions.

It was in the second grade that we could become confident in the gifts that we gave her. She showed us that she would like a special spring Easter basket with these items tucked inside (Picture 3.7). Oftentimes we found pictures of tables set with food or cakes labeled with our names (Picture 3.8). It tickles me to see that she even included how her sister Marcia's breakfast should look.

In the fourth grade, Kim began to verbalize more, but many times we had no idea what subject she was talking about. Without a frame of reference, our conversations were very confusing. It wasn't until I was cleaning the living-room one night after one of her all-night drawing blitzes that I found out that she had her own way of setting up the subject she wanted to talk about.

The sketches of the "Santa Dog" are good examples of the first papers giving context to the subject. Kim introduces the setting in the first (Picture 3.9). Then the second paper illustrates the idea she needs to communicate. She's taking our focus, showing us what she wants us to pay

Picture 3.7 My Easter basket (8 yrs)

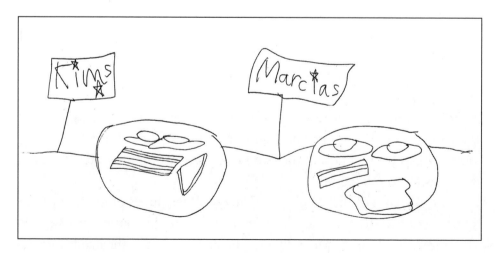

Picture 3.8 Marcia's and Kim's breakfast (7 yrs)

attention to. It's like explaining to us, "There was a Santa Dog, and I wrote him a letter saying…"

The dog is walking, perhaps to the table. In the next drawing (Picture 3.10), he is sitting at the table reading. She uses the letter as an insert within the drawing to show us what it says. Notice the note that he is reading on the desk is turned toward the viewer. In the insert, the small piece of paper is taped to the incorrect side. I believe she did this in order for it to fit the page. I did find a piece of paper that was fashioned and written just like this dog's letter. Unfortunately, I threw it away. I often didn't know what might be important material to keep, until after the fact.

Picture 3.9 Santa Dog (8 yrs)

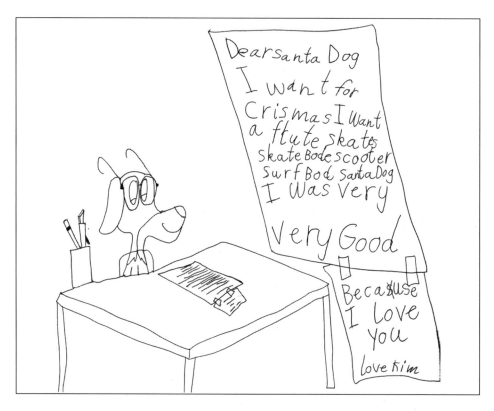

Picture 3.10 Santa Dog letter (8 yrs)

Ironically, it wasn't until much later in life, when Kim was trying to verbally introduce a subject for conversation, that she found it difficult to start at the beginning.

Without establishing a context, she blurted out, "Aren't you glad Jack's dead?"

I raced through my brain; no one that we knew had died recently. Then I went through the list of pets that might have passed away. I shook my head, indicating that I didn't know who she was talking about.

"Jack Dawson." She sounded a little exasperated. There was no doubt I was missing something. I shook my head. "From *Titanic*," she said.

It all came together then. We had seen the movie several months before, and my mind was on other things. This was not the first time she started in the middle of a subject and was rather impatient with us for not keeping up.

The speech therapist was very helpful in establishing the rules and structure for conversation. She was able to instill a sense of how important

it is to communicate effectively and clearly, not only for the listener, but also to cut down on Kim's own frustration. There were many more drawings that followed as Kim's way of exploring how to inject a context into what she wanted to say. It was always easier for her to do so on paper.

To clarify just how Kim's language developed, we must examine the progression of events. In the beginning, she was a screeching non-verbal toddler who was frightened and frustrated. Because she was a visual learner, special education professionals encouraged sign language in tandem with modeling verbal language as a way of helping her connect words with the gestures she was seeing. It seemed as though Kim was not picking up language as easily as other children her age. The questions of "who," "what," or "why" were not present. Although every word had to be taught to her, through the course of many years her vocabulary and ability to verbalize grew exponentially. However, the capacity to communicate was splintered into different parts of language. There were times when she could be clearly understood with spontaneous speech, while in other instances her utterances came out in three-word spurts as she turned the words around in her mind, combining fragments from her catalog of echolalia into a patchwork of meaning. A large part of her speech at the age of 11 included expressions that were still comprised of the same visual references. In order to understand the point that she was trying to make, a person would have to be familiar with the immense library of auditory recordings that she stored in her mind, and where the reference originated in order to understand the context.

Every year since her attendance at the specialized preschool, Kim was evaluated regarding language skills. There were many parts of speech that needed to be examined, not just the ability to pronounce words. The main issues were initiating conversation, spontaneous/expressive language, receptive language, and context appropriateness. A person with autism can be verbose and yet not understand a direction given to them. They can have the answers ready in their mind but not be able to begin a conversation to express what they know. In other words, their language, the skill to express themselves in all areas may not be present 100 percent of the time. Kim's abilities were split into different portions. She could receive and understand verbal parts of speech (commands or questions) on many occasions but on others it would be confusing for her. In some instances,

she could say a nicely constructed sentence and then she would struggle with the next. Of course, the unknown variable in those situations might have nothing to do with language, but with changes in routine, heightened stimulation, or changes in environment.

The speech pathologist and child psychologist, understanding the lack of consistency in all environmental settings, asked me to determine and rate the frequency in these areas of her language. At the beginning of junior high school, she could begin a conversation 45–50 percent of the time; however, quite a large part of her communication was still subject appropriate echolalia, tangential in nature and telescopic. As she answered questions, she utilized words and thoughts that had very little connection to the subject, tying them together like a bridge until she arrived at the point of her answer. After years of speech therapy, focusing on the structure of a conversation, turn-taking and developing the connective tissue of subjects, she became more confident in her speech.

After making her transition to junior high school, Kim received her first progress report for language arts. The teacher stated that she was in the top 20 percent of her class. I was dubious. In casual conversation with my friend the Principal, I mentioned that I thought the teacher was being terribly optimistic. My friend told me there was one way to find out, so we went to her office and looked up the records. It was apparent at this time that Kim was more articulate in her written language than when speaking.

During the last four years of public school, Kim had many research papers to write. She had to go through three versions of one report before she arrived at a rough draft and two more afterward to have a polished final version. John and I both helped her to recognize and remove favorite phrases that she incorporated into her everyday speech. For a visual learner, it was an excellent way of showing a more direct approach to expressing herself. She learned how to distill her thoughts into increasingly clear and concise sentences.

When she graduated from high school, as long as she was familiar with the listener, she could impart information using spontaneous language (her own words) with an average of 80 percent proficiency. The listener had to be patient in waiting for her response as she searched for her own words to use.

Depending on the context of the situation, Kim can be very articulate in a college classroom setting asking well-framed questions and providing amply filled answers. Yet, upon meeting an unfamiliar person in our home, she often finds it difficult to maintain a smooth flow of language. As a family, we are so accustomed to mentally filling in the gaps of her communication in our own minds that we really don't notice that she is speaking in a halted manner. She has been working diligently to give herself time to think of the words to frame her sentences before she responds. There are now times I find myself pleasantly surprised when speaking with Kim, because she is using smooth complete turns in conversation. She is still building her vocabulary, asking questions and dissecting the meanings of words or common clichès.

At the present time, Kim turns in her college work without advice or assistance from any of us. She has also received compliments and encouragement from her language arts instructors on her writing style.

With suitable preparation, such as touring an unfamiliar room, drilling her with possible topics of conversation or questions, introducing her ahead of time to the people she hasn't met, we can minimize distractions and unwanted stimulation from the environment to give her as much ease as possible when speaking at an important event.

Living with a person and knowing their habits doesn't always bring familiarity. For many years I ached to know my youngest child. Once she was able to verbalize, communication was one-sided whenever she was in the mood to verbally impart information, and that was usually a mechanical regurgitation of facts. It was far from any intimate or personal facts about herself. The sketches that she drew along with her work in other art mediums filled in the expressive parts of her speech and body language that were missing. The artwork added information that we couldn't ascertain from her exterior demeanor, such as her sense of humor, her values, and her personality. The artwork conveyed with an incredible clarity precisely what she wanted to say.

From the time Kim was born, she never sought me out for comfort and treated me many times as a tool rather than a person. I often wondered about who the person was inside my youngest child. At first I ached to hear her voice, then to know her character. Years went by and, although she slowly learned to speak words, construct sentences and be subject appro-

priate, all of the forms of communication did not come together in concert to be understood in all environmental settings. Meanwhile, her drawings were showing us far more than words could say, revealing her intellect and cutting through the mire of echolalia. The process of waiting for her to speak or to write was at an agonizing pace, but at last, when the drawings came, I could receive the personal communication of her joys, sorrows, and her pride at being an autistic individual.

Chapter 4

Emotions

As an infant, Kim did not develop a social smile or light up with a look of familiarity or recognition. When she was born, we received a baby calendar where you record baby's first laugh, first word, first tear…It was a long wait. In time we abandoned the calendar altogether. After she learned to talk, her affect was quite flat and mechanical. Most of the photographs taken of her reveal a child with head cast down and a blank face. Any question was either answered with a "yes," or "no," but usually just silence. On rare occasions she would smile and even then it was at something that amused only her. She never really cried with an emotional feeling, but rather more of a screeching sound when she was upset. It was puzzling. I never had the impression that she was angry or sad, more that it was a frightened response. When someone is crying from a wellspring of passion, it is usually apparent by the look on their face or the tension in their body language. She easily expressed agitation, fear, and frustration but that was basically all that we knew of Kim. Tears were never present. It wasn't until she was five years old when she learned her first real emotion.

CRYING

Around Halloween, we had a tradition of watching *It's the Great Pumpkin, Charlie Brown*, a movie based on the cartoon strip developed by Charles M. Shultz. Kim was especially excited, not because she understood the custom of dressing up and getting candy, but because of the fun movie that we

taped for her to watch as often as she wished, which, by the way, was constantly.

One night, Kim indicated that she wanted to watch a certain segment of the movie over and over. As I watched her view the scene, she flapped violently. When she was little, she bounced up and down on her tiptoes also.

This evening, she was thoroughly enjoying, over and over, the part where Snoopy, as the "World War I Flying Ace," dances on Schroeder's piano until the music turns sad and Snoopy begins to cry. I finally told her that we had to let the rest of the tape play because I was afraid we might wear out that section. We watched the whole show several more times that night.

About a week later, Kim approached me and signaled for my attention. She squinted her eyes, made a whimpering noise, and said, "Crying."

"Yes," I said, "That's a little like crying, but crying makes tears. Tears are water that runs down the face when someone cries."

Kim looked satisfied and off she went to run around in a circle, looking out the periphery of her eyes. I thought that was the end of our communication on the subject until one day, about a month later, I found her staring strangely into the negative reflection of the microwave door. Slowly, I turned her towards me. Tears were running down the small, round, emotionless face. Quietly and calmly she asked, "Crying? Crying?"

"Yes, Kim," I said, "That is crying."

She just stood there for a long, long time watching the tears fall and wiping them away with a nearby T-shirt.

MAD

After being involved in the special preschool that educated many children with different disabilities, I befriended a woman whose child was visually impaired. She told me about a bright neon pink-colored stuffed toy that her daughter was able to track with her eyes. Unfortunately, the cost of the toy was way out of their price range. It was ridiculous that such a small plaything could be priced so expensively. I found a pattern to make a doll, some neon pink fabric and some black paint for the face. I whipped up a

doll in no time at all and it wasn't long before the toy was sitting on the tall bookcase with the face freshly painted. Kim, who was always curious, scaled the wooden case with no effort at all. She pressed her fingers into the paint and smeared the face.

I caught her in the act and decided to teach her a lesson about mad. I told her that I was mad. "Mom is mad." I repeated it to her stressing the word "mad." After several times, she seemed to get it. She began to cry and say, "Mom mad." I let her stew about it for about ten minutes. "Good," I thought, "It's sinking in." However, she didn't stop. She seemed to calm down over the concept of her mother being angry with her but, unfortunately, it was as though she were reliving it over and over. Every 10–15 minutes, after she settled down, she burst into a writhing upset. I would just try to calm her down by reassuring her that I was no longer mad and that I "forgave" her. "Mom is *not* mad anymore," I told her, but it had no effect.

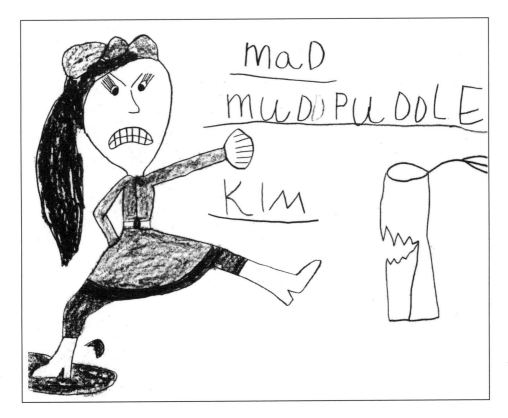

Picture 4.1 Mad at the mud puddle (7 yrs)

After an hour I didn't know what to do to bump her out of this sorrowful groove she found herself in. I tried everything to show her the fact that I forgave her, John added his reassurances, but nothing was working. Finally, I resorted to using a movie to distract her attention and wondered if we were ever going to be able to correct or discipline our daughter in a way that would be meaningful.

Years later, after a very difficult morning in first grade, she was able to show just how mad she was. On the way to school, while trying to walk down a steep bank, Kim slipped and fell down in the mud. The drawing (Picture 4.1) said it all but the fact that she wrote words added emphasis to what she had to say.

TEENAGE YEARS

Most of the drawings that were developed during the years of elementary school age were filled with happy, playful relationships with classmates or animal characters from cartoons. It wasn't until Kim attended junior high school that all of that changed in a dramatic way. The series of drawings that deal with emotions are very telling not only from an artistic point of view but also in showing Kim struggling as all typical teenagers do. During the junior high school years, she went through many types of transitions: physical changes of environment, new and different classmates, an increase in the number of classes along with the shift in homework load. As any parent of a young adolescent will tell you, that is nothing new.

There were many emotions that she experienced as a teenager, crying being one of them. Numerous drawings came to light as I was putting them away in her precious portfolio. One of them demonstrates her feelings as she wears a mask that shows others that she is happy and content, while the tears squeezing out from beneath tell another story. Physically, Kim hates to cry. She often wondered why the tears came to her eyes and complained about not being able to control them. All of the soothing words about it being a natural response were lost on her. It was not as though she felt that shedding tears was a sign of weakness, but she abhors the act of crying. She hates the physical reactions that her body has when she is compelled to cry.

Many of her drawings do not need to be explained. A person can sense the impact of what she is saying. However, without the correct context and information, a person viewing these samples might come to the wrong conclusion. There were small clues in Kim's drawings—not only did she look disengaged with her peers but a person could gather the full meaning by looking closely. In one of the drawings (Picture 4.2) she has the word "reject" and a symbol with a slash on her desk. She hides her classmate's identities by casting them as super villains. The teacher's nameplate was on the back desk, which I have blocked out. Kim felt like an outsider, like she didn't fit in. The teacher, she explained, did not call on her to respond with answers as often as her peers. She believed it was because of her autism and therefore felt as though she was perceived as a lesser person than she was.

The difficult and emotional time for teenagers can be compounded by having to deal with the disabling forces of autism. This stage in life is when most individuals analyze and discover who they are and where they belong in the scheme of things. Autistic people go through this as well.

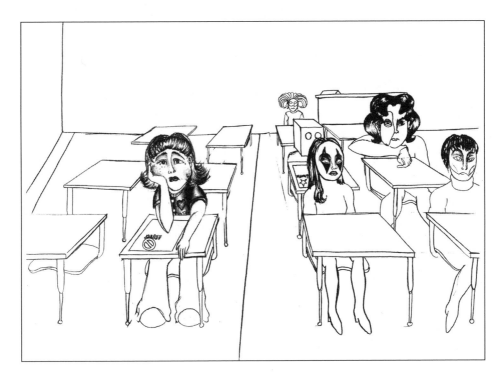

Picture 4.2 Reject (15 yrs)

Kim had not shown that she was aware of anyone else's opinion of her, nor did she seem to care. When, as fifth grade came to a close, she was informed she was autistic, she railed against the idea of being different (see Picture 5.4 in Chapter 5).

John and I explained constantly that very few of us who live and breathe on this planet are not affected by physical or mental challenges of one form or another. Our neighbor across the street lived with fragile diabetes; some people wear glasses or hearing aids; some use canes or wheelchairs. I believe what distressed Kim most was that she wasn't perfect and she wanted to be a flawless human being.

All adolescents want to be good at something. Some want to excel at many things. Kim wanted to be perfect and nothing less. She spent several nights devastated, bemoaning the fact that she wasn't as gifted as Albert Einstein, Amadeus Mozart, and Leonardo DiVinci. I pointed out that most of those people were not really appreciated for their genius in their own time. It didn't matter—she wanted to be no less than multi-talented and gifted. We were concerned about the influences shaping her opinions regarding her self-image. Of course we wanted her to have high standards but not impossible ones. It was a tough balance between building her self-confidence and deflating some pride.

Junior high school can be a tough place to discover who you are, especially if you are a few years behind in social development. Typical teenagers as well as teenagers with disabilities often experience bad days when someone says unkind things or calls names (see Picture 4.3).

In the drawing of the dual personalities (Picture 4.4), Kim reveals on paper what many kids her age feel inside. She says, "The genius side is how my family and teachers see me. I have the goal of being a genius and have a haunting desire to achieve. The other part of the character is how my classmates see me." Notice the straitjacket and the written word, which is a reference to "Doofie." It comes from a teenage movie whose unpopular character is supposed to be mentally challenged.

There were various compositions where Kim explored a whole array of dark, hurtful feelings in the picture depicting her clothed in a straitjacket once more, sitting in a padded cell. In other sketches of the same padded room, there is an observation window where she is under the watchful eye of people in suits.

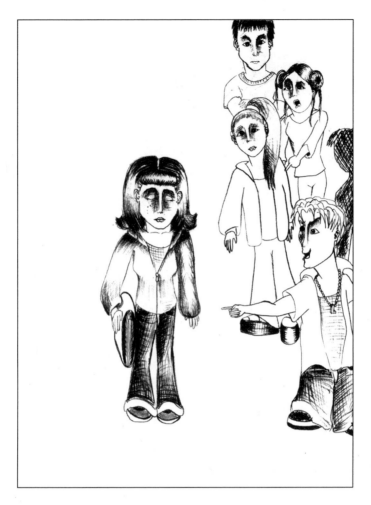

Picture 4.3 Jeering (14 yrs)

Picture 4.5 shows herself being observed by a camera and surrounded by objects. She explained that she felt like a lab animal or an experiment. I could understand why she began to feel this way. For years she had been observed, her progress carefully charted for reasons of planning out her education program and strategies for changing behaviors. The first observations were carried out by the Early Intervention people, then the school staff and finally the state board of education. All of this had gone on for a number of years, when only recently it had come to her attention. She was sorting out just how she felt about all of this new information being revealed *to* her as well as *about* her. Her drawings afforded her a way to explore many feelings at this time.

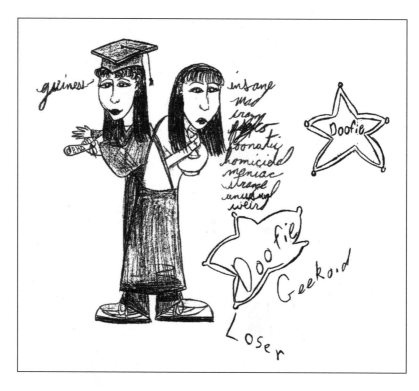

Picture 4.4 Genius/Insane (13 yrs)

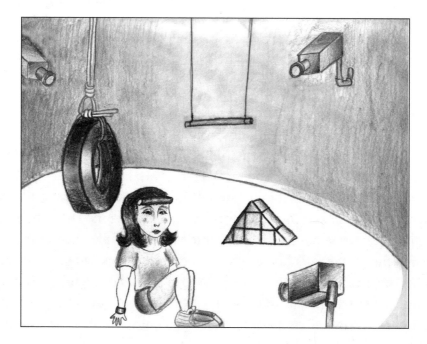

Picture 4.5 Observation room (13 yrs)

ROSY YEARS

Like a child encased in ice slowly melting though the years, many of the disabling effects of autism have melted and fallen away from Kim. As she warms up to the world around her, she develops traits that are evident in typical children from birth. In previous sections I have explained how she learned different emotions, but just when I thought she had evolved into the character that would define her personality, she surprised us by another emotion: nostalgia—looking longingly back on the past with fond memories.

Kim had previously never shown any sign of homesickness while at summer camp, or wistfulness regarding persons or events. It wasn't until she would move on to a new phase in her life that she reflected on people and characters who had shaped her years in junior high school.

In this picture (Picture 4.6), true to Kim's style, she categorized the teachers according to the subject and grade they taught. Kim is in the center of the page holding a rose as well as a graduation cap. It was important to her to show the commemoration of the 11 September tragedy and her fantasy of being the school "survivor" (a reference to a "reality" television show in the United States). Her treatment of the teachers is one of admiration and affection, many of them her dear friends. The palette-faced characters at the top of the drawing were ones she developed for a charity event and therefore regarded as a triumph. In the lower left corner, Kim includes the villains of her junior high school years such as Mr. Fiend, the characterizations of super villains who plagued her life. Finally, she looks towards her future life, to the hope of higher education (the graduation cap), travel (the globe), and culture (theatre mask).

Kim feels strongly as an advocate for individuals with special needs. When she grew old enough to understand, she read books regarding autism. An autistic individual diagnosed a little over 30 years ago would most likely receive the label of "severely retarded" for the lack of a better diagnosis. Kim feels a special affinity with individuals who have the disability because she could have been born in another place in time and been treated quite differently. After hearing the slur day after day at high school, she drew Picture 4.7.

Picture 4.6 Rosy years (17 yrs)

Picture 4.7 Until I disappear (17 yrs)

"I am the person with the 'R' on my forehead (notice the moles on the face). I am felled by the impact of the word. But I am also the girl standing off to the side. That is how I feel when anyone calls someone else a 'retard.' It takes my breath away, and I just slowly fade until I disappear."

OF MICE AND MEN

This was a way to fight back and to educate those around her. Nowadays, the words "retarded" or "retard" are thrown around carelessly, in the society where we live, as a derogatory term. It is so hurtful because some of Kim's wonderful friends have mental retardation. The emotion she feels is very visceral, almost beyond words. She is very disturbed that most students her age don't use the word respectfully and are hardened to its sting.

As I have stated before, I have conducted a meeting every year before school starts to show the teachers drawings that Kim has used to communicate her feelings. I have made them aware of the fact that we are a part of the disabled community, a point that many teachers often forget. It is hard for Kim to watch a movie in class that features a fictitious character who has mental retardation only to have classmates jeer and make fun of the disability. Some are malicious in their remarks while most are just parroting the words out of ignorance. Those teachers who attended my meetings took in the information and reflected on it accordingly.

One year a teacher did not attend my meeting for whatever reason, and did not receive the information. A week later, the incident happened. As I was sitting in my car, waiting to pick Kim up from school, she slipped in and burst into tears. It took quite some time, but I dragged the information from her. She told me she was "*NOT* going back to school…*ever!*" Since she enjoyed school so much, it was heartrending to see her so miserable that she didn't wish to attend any more. I made some phone calls to find out what was going on.

The literature class was having a discussion, nothing regarding individuals with special needs, when a student used the word "retarded" as a slur, with no animosity, unknowingly packing a powerful punch. Instead of using this moment as a chance to teach, the educator repeated the word mirroring the student's sentence and went on with the conversation. A

prime opportunity was missed to open the minds of these students regarding the word "retarded" as a derogatory term as opposed to a "retarded" individual.

What I had to focus on at this point was how we were going to build a bridge between both sides of this situation. I called a meeting with this educator and showed him the drawings that he would have seen if he had attended the meeting. He was stunned, and stated he had no idea that Kim felt this way. I felt bad for him, obviously a caring man with many degrees in education. We both talked to Kim who was not easily swayed; she felt bruised and betrayed. This was during the first week of school and they had started off badly. After class each day, he checked to make sure she was feeling alright with class discussions, and she in turn gave him her impressions of the literature they were talking about.

There was an anticipated bump in the road when we found out that the class would be reading the classic, *Of Mice and Men*. The book's premise hit Kim right where it hurt the most. It is about two men who are tentative friends, during the American economic depression, who go from town to town looking for work at a time where jobs are not plentiful. They settle into a working and living situation that seems to be the answer to their plight, until one of the men (who has mental retardation) gets into trouble and they both move on to another place to work and live. This is the cycle of events until the typical man realizes that his retarded friend is in an inescapable predicament, and murders him.

After this first incident between Kim and her teacher, I didn't know if this subject could be handled sensitively enough. First, I asked her if she wanted an alternate reading assignment. She declined because she wanted to be educated equally with her peers. I warned her that it would be difficult, that class discussions could be hurtful. I prepared her by renting the movie adapted from the book weeks ahead of time so that she would be able to sort out her feelings. When the literature class began the discussion, the teacher was most sensitive to others with disabilities and made sure that the class used respectful terms when referring to the mentally challenged character in the book.

After navigating a very tricky minefield, both Kim and the teacher developed a relationship of mutual respect. He learned more about a fresh and different perspective on the works of literature that he had been

teaching for over 20 years, and she extended her trust to him that he would support students with special needs and culture in his classroom. He was a fabulous teacher, encouraging her to look for deeper meanings and themes behind the characters in the story. She could have chosen an alternate assignment, quit the class or changed teachers, but she learned so much more by working the issue out. By doing so, she learned another emotion that she had not yet been able to process one that was very difficult to achieve because of such a keen memory—the ability to forgive.

"No disabled" (Picture 4.8) is a drawing that shows the soul of a girl who makes disparaging remarks about individuals with special needs. There was a classmate who, for whatever reason, voiced her opinion that people with special needs did not belong in our community or society and had nothing to contribute to human kind whatsoever. Obviously this student had a very limited view of the world, not touched by any individual with special needs.

Because this was a government class, the teacher did not feel he should moderate any kind of balance in students' views. After all, he wanted the free flow of expression. The government course was all about students discussing laws and the rights of individuals. It distressed Kim that there were so few in the room who offered to speak about the contributions handicapped individuals have made in society. She took to heart those who reacted in a negative way. Her peers were responding to hypothetical situations posed by the teacher. For Kim it was personal. It was a rejection of the worst kind. Classmates made statements discussing issues they had limited knowledge of and with little information regarding disabled individuals. Kim felt the balance of argument weighed heavily against people with disabilities and decided to use the only language that she felt confident in using. As she showed me this drawing (Picture 4.8), she explained: "Every day this person wears a mask that she presents to others." Kim reveals her opinion of that girl's true identity behind the mask. Notice the necklace fashioned to hold up this girl's top—it forms a slash through the wheelchair emblem. The meaning is quite clear: "NO DISABLED."

You might wonder why it was a huge issue but, at this school among the loudest voices, tolerance for individuals with special needs was in short supply. Kim fought back very articulately with a silent clarity. In a quiet corner during art class, she used the materials at her disposal. Many of her

Picture 4.8 No disabled (17 yrs)

fellow artists respected her work and ability, often complimenting her style. They may not have understood the meaning behind the drawings and paintings, but the mystery of the subject pulled them in, they wanted to know more.

The painting entitled, "Everyday at school" (Picture 4.9) shows typical students laughing and making fun of the individual with special needs, as he is being guided by a teacher while doing chores around the school. Kim watched many of her fellow students make fun of the special education

Picture 4.9 Everyday at school (17 yrs)

Picture 2.15 Fractals (16 yrs)

Picture 4.9 Everyday at school (17 yrs)

Picture 6.9 Exhaling beauty (19 yrs)

Picture 6.10 Finding my niche (19 yrs)

Picture 7.5 Candle-lit prayer (16 yrs)

Picture 7.8 2005 Oregon Walkathon design (16 yrs)

Picture 9.9 Light spectrum (15 yrs)

Picture 9.10 Craving liberation (17 yrs)

student day after day. It compounded in her mind until she couldn't bear it any more and decided to do something about it. The assignment in art class was to choose a style of painting and render your own view and composition, utilizing that particular method. She picked the German Expressionism style.

Picture 4.10 Hear my lamentations (17 yrs)

What is interesting is that Kim often makes references to her previous paintings in other pieces of work. For instance, after reading Dante's *Inferno*, she drew her own rendition of such a place including a small imitation of German Expressionistic painting. She entitled the drawing "Hear my lamentations" (Picture 4.10). Kim is the small figure tossing her drawings out, revealing them for all to see. The students in the sketch finally grasp her meaning, are shocked, ashamed, and mortified at their behavior. Kim always felt that, if the people who attended school with her knew the impact of their words on others, they would not utter them. Kim likens the "R" word to a racial slur, a type of hate speech, which would not be tolerated in the classroom or on campus. Not all of her classmates were

callous and unfeeling towards individuals with special needs, but some were less sensitive and usually possessed voices that rang out louder than others without any restraint.

EXPRESSIONS OF GRATITUDE

Our neighbors had no idea what was going on in our house across the road. Since birth, Kim howled and screamed, rarely letting up. It was a wonder that the child welfare agency wasn't called on us. As she became a mobile young child, she often slipped away from me, which is mainly how we got to know our neighbors. One day she got away from me as we were walking home from her grandfather's house. Right away she was up on the doorstep, staring at a circular wind chime, when I met Mike. He lived with his wife Carol and daughter Mariah in the house across the road. He asked me some questions about Kim, and then I took her home.

Shortly thereafter, mysterious gifts started showing up on our doorstep. It started at Easter one year and began to encompass many of the other traditional holidays. This family discovered a way to engage Kim without being threatening. At first, I was alarmed at the effect it might have on Kim because of her wariness of surprises. They signed the first note, "The Easter possum," and from then on the notes were signed by the "possum" of the appropriate holiday. Kim seemed to accept these items easily when an animal was the instigator of all the fun. She drew pictures of all kinds of adventures and various scenarios the possum would find himself in. Over the many years while visiting their home, we saw Kim's drawings posted on the refrigerator.

Mariah grew into a mature teenager and became a trained babysitter for the Respite Care program. She took care of Marcia and Kim so that John and I could have a much-needed break outside the home. Carol was a great support, having worked with adults who had special needs. Whenever I required some advice or a sounding board, she was an incredible resource of encouragement to draw from. If you could ask someone to describe Mike…well, he was just Mike! He was an unconventional and incredibly generous man who shared the essence of himself with everyone. Each time that we met, he had a new joke to tell or funny story at the tip of his tongue.

There was always a chocolate candy kiss in his pocket for a bank teller or a special flavored Lifesaver's™ candy at the ready to bring a smile to someone's face. Funny thing was, he never met a stranger and treated everyone equally.

He was one of the most ardent patrons of Kim's artwork. At several charity auction events that featured her work, he purchased it for many times the price expected even though, if he had asked, she would have given it to him. There were times when she had too much stimulation in the course of her school day and could not go to the special auction event that she was supposed to attend. Twice, she missed the annual event because there was just so much disruption, so much noise that she could not consider any extra-curricular activities in the evening. There was a knock at the door. I opened it, there was Mike bearing a grin with a toothpick in his mouth and the T-shirt she had designed and autographed from the annual Oregon Autism Walkathon. He had outbid everyone for it.

During her sophomore year in high school, Kim entered an art contest that was held on the east coast. Mike was so kind to give us airline tickets for the trip. When we came back to Oregon, Kim desperately wanted to express her joy and gratitude for such a wonderful gift but could not. She wrote a paper for school telling of the experience she gained from the trip (a copy given to Mike), but she felt that the words were inadequate. Many times she looked across the road toward their house and told me that she would really like to go and give Mike a hug. She knew that it was a way to express the emotions that she felt but, at the same time, the physical closeness was too much. I urged her to do it, but she couldn't quite bring herself to that point. I always felt there would be time for her to mature and find the mode of expression in conjunction with the words to tell this man just what he meant to her.

Time passed by quickly and before long our neighbors were attending the small quiet graduation gathering in the backyard, two weeks after the official school ceremony. It was a summer of changes for Kim. She was saying goodbye to her childhood, her high school, her long-time friend and companion, Louie, who had passed away. The Easter possum had retired and moved on to leaving surprises for his grandchildren. There were a lot of life-altering adjustments to be made in a compressed amount of time.

About two months later, there was news of an accident, and we would have to say goodbye to our good friend Mike too. One thing about a person who lives in a large way is that they leave an incredible emptiness when they go. All of us were heartbroken, finding the words difficult to say, the emotion too hard to comprehend. We were choked up with feelings for our wonderful neighbor. Kim withdrew quietly to her room and emerged with one last drawing, honoring Mike and the Easter possum. She circumvented the inability to express what she felt verbally—the emotion too deep—and finally utilized the only way she knew to adequately thank him for his friendship, generosity, and love.

It is a continuing growing process as Kim makes new discoveries in life. The difficulty lies in finding the balance between positive experiences and negative feelings. As typical people, we have to sort out what new beginnings and losses mean to us. Kim will have to do the same as she uncovers the emotions that lie quiescently within.

Chapter 5

The Art of Education

There is an element of art in the profession of education. It doesn't have to do with the knowledge or proficiency that an individual has of a subject such as mathematics or writing. Many people can be vessels and contain the knowledge. The artistry lies more in the ability to impart the information to others. Some of the best educators I know are, in fact, students themselves in a never-ending quest to learn.

Since autism affects people in many different ways, it is difficult to apply an absolute and generalize. What may work for some may not work for another, and yet the characteristics for autism remain the same. In order to understand the keys to open up learning for Kim, she had to show us what having autism meant for her. It was up to us to observe, to analyze, to search for the answers as she defined for us the rules she needed to live by. In other words, she became the teacher.

When it came time for her to make the transition from the Early Intervention preschool to a public school kindergarten setting, I had my concerns. Public school had evolved to mainstreaming the special education students into the typical classroom. "Mainstreaming" was a way of educating students with special needs separately, then including the student in carefully selected classes or lessons that were adjusted and made suitable for the needs of the disabled child. This was a way of giving handicapped children an outlet for social time with the typical population at school.

The Early Intervention preschool's model of instruction was reverse integration. The staff started with a class comprised of children with special needs and placed children with typically developing skills into the

classroom to serve as peer models. This method of education worked well for Kim because her learning style was based on patterning and modeling. Because autism causes an individual to process information visually, she needed to have typical models (children) to show what was appropriate behavior.

At the time of Kim's diagnosis, there was a new and upcoming method called "Inclusion," which suggested that it would be best to place the child with a disability in the neighborhood school and classroom that they would normally attend. Accommodations and modifications would be made to the lessons or classroom environment to ensure that there was equal opportunity for a typical education. Consistency is the key to organizing information for a person with this type of disorder. By having inclusion as the model of instruction for the public school, Kim would have exposure to an average model of typical behavior all day. Only having an hour or two out of the day to observe or emulate typical behavior, mainstreaming would have been a poor system of education for my autistic daughter.

Choosing the appropriate education method in a safe environment was critical to Kim's education. Equally important was her ability to draw; her art opened wide the door of educators' hearts and minds to teach this very challenging student.

WE'RE GETTING THROUGH!

Even though Kim had been attending kindergarten for about three weeks, the teachers had their doubts about her placement in a typical classroom. They told me that up to this point they could see no evidence of Kim absorbing any material they were teaching. One evening, about a week later, she was consumed with drawing. It was not unusual for her to draw on more than 50 pages at a sitting. Her body was rarely still as she could draw from any angle. The paper stayed in the same place as she moved herself around the page. This particular night, she was counting out loud, although inaccurately.

"One, two...five, six...three, four..."

"One, two, three, four, five, six..." I corrected her.

Kim was stubborn. She kept counting in the same manner. I tried a few more times and gave up. Nightly, before going to sleep, I tried to gather all the papers together so John wouldn't have to wade through them in the morning. I glanced through the stack I had in my hands. Kim was definitely working on a theme of some kind. Most of the pages showed a chicken, some three-dimensional planks, a door, and a shoe. I knew it must mean something, but I just couldn't see it.

John took his turn at trying to solve the puzzle and came up with nothing, but both of us believed it was familiar. I brought a copy of the drawing along with me when I walked Kim into class the next day (see Picture 5.1). The teacher and assistant were not particularly busy at that moment. As I produced the drawing from her backpack, I mentioned that Kim was counting the whole time she was drawing. I placed the page in front of them.

"Does this mean anything?"

Right away, I could tell it was significant. Their eyes grew big. They were excited.

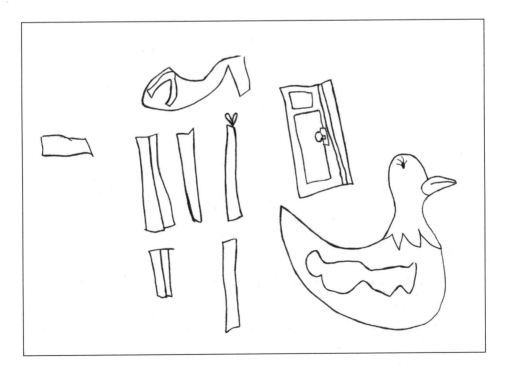

Picture 5.1 Buckle my shoe (5 yrs)

"Our poem for this week is *One, Two, Buckle my Shoe*," they said. From that moment on, Kim was treated with more respect as a learner. It wasn't that they didn't appreciate her in the beginning, but they now saw her as a child who had potential, who could be reached, who could communicate, who could participate. She had become a member of their class.

It wasn't long before teachers, assistants, and aides developed a fondness for Kim, especially one assistant. They now knew that she wasn't a child who threw tantrums as a means to get what she wanted but that they were the expression of an extremely frustrated kid. They became familiar with her learning style and personality between the pages of the journal and her drawings that we sent back and forth from home to school and school to home.

Since kindergarten convenes for only half of the regular school day, I took the time each day to get some much-needed rest. Kim was still not sleeping consistently through the night. When I came to pick her up after her first day, I was met at the door by the teacher, the classroom assistant, and the learning resource center assistant. They tried their best to put a positive spin on things but they all had concerns.

"She needs to talk in an 'indoor voice.'" Because Kim processed her information visually, and the idea of an "indoor voice" is difficult to put into visual terms, I knew the first few weeks were going to be a rough adjustment. If they only knew her, they would understand that there was no malice or manipulation of any kind behind her actions.

Sometimes the entries were strange requests:

Could you ask Kim to stop reading the children's names out loud that are being written on daily awards? She is reading them upside down as I'm writing them, and they are supposed to be secret!

Some entries were wonderful stories of Kim interacting with the other children:

Kim did something sweet today. We have a "star of the week" interview where we ask each of the children to say something nice about the star (chosen child). When I asked Kim, she went over to the playhouse area to get a dress and hat. She took it over to the star/child and wanted to give it to her to wear. I thought it was really cute and a kind gesture.

It was obvious that Kim could not understand the verbal directions, but did her best to convey friendly feelings.

Things were going along fine in the classroom. When I say fine, I mean that Kim fully cooperated to the best of her ability, and the staff gave her time to grow into kindergarten skills. The education staff came to know her through the papers that showed her delight with life. But naturally, as recorded in the daily journals, there were a few setbacks along the way, an occasional regression or error in communication.

As Kim grew older, teachers continually expressed their concerns that she wasn't able to show a one-to-one correspondence. In one particular assignment, she was instructed to count the seeds that were in a slice of apple that was set before her, then write the appropriate figure in the blank. To show that she understood the concept, she was supposed to make a drawing showing the correct corresponding number of seeds in the apple (see Picture 5.2).

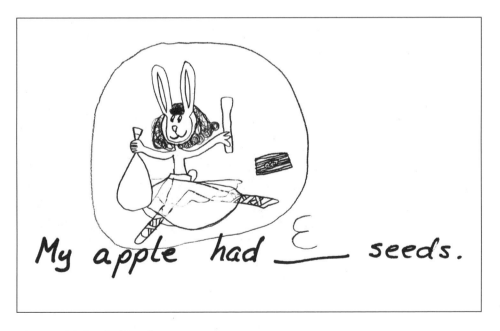

Picture 5.2 Seeds (6 yrs)

This indicates to me that the problem resulted from the lack of ability to communicate the instructions to a child with autism. Kim was a visual learner. The directions were probably given orally and, therefore, she did

not comprehend what was being asked of her. It appeared to others as a lack of compliance or intelligence. Drawings at home reflected that she indeed did understand the concept, as she reveals in the drawing of the table settings.

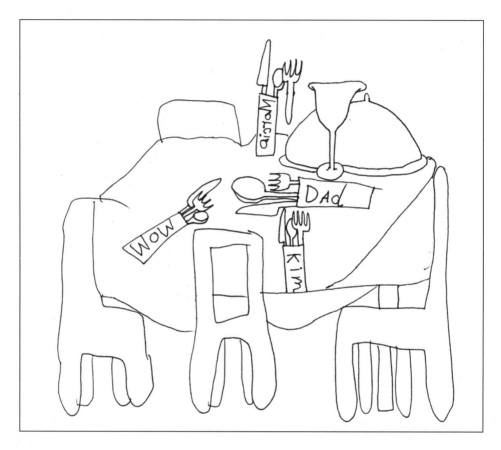

Picture 5.3 One-to-one (6 yrs)

(Picture 5.3 was not done following any directive or prompt.) There is an appropriate number of table places for each member of our family with our names labeled at the spot. These are prime examples of how important giving the appropriate instructions for a particular learning style can be. By making small adjustments in the delivery of directions, a visual learner can participate as an equal member of the classroom.

In second grade, the teacher brought up the fact that Kim had a problem with sequencing and understanding the order in which events happen or the steps involved in performing a task. However, that all

changed later in second grade when Kim produced this series of drawings (Picture 5.4).

Looking at her work is almost like viewing a storyboard for a movie. She moves the viewer to see the story she wants to tell. I discovered these drawings one night as I was picking up the papers from the living-room floor. At first, I thought she was being perseverative because of the number of boxes but, after I looked more closely at the drawings, I found that they were a sequence. I placed them in order and flipped through them. They made a little motion picture. (One thing to note is that she didn't place the pages on top of each other to flip back and forth while drawing as the animators do.) I took these seven separate drawings to the teachers to show why I thought she understood the concept of a sequence.

"Pezza Jam" was inspired by the basketball movie, *Space Jam*. Although my girls never went to see the movie, they saw commercials on television and our neighbor bought them "Space Jam" t-shirts. Kim misspelled the word "pizza."

Picture 5.4 is a series of seven drawings. In the first drawing in the upper left-hand corner Kim introduces the context or setting of the subject with a character wearing a basketball uniform beside a coin box. As the viewer's attention scans the series of sketches, starting at the left hand and moving right, the drawings give the impression of a coin falling down into a slot in the top of the box.

This sequence is important because, first, it shows that Kim obviously understands that events occur in a certain order. Second, she shows that objects are moving from one point to another. Finally, the three-dimensional quality of the objects shows that they occupy a space. Perhaps Kim's vision was so acute that she could see objects move in slow motion or at least, by breaking down the action, visualize frame by frame in her mind.

CONFIDENTIALITY ISSUE

Team building was essential. As long as everyone shared information and coordinated as a team, the implementation of Kim's education plan went smoothly. It was when the journal was abandoned and considered to be an outdated tool that the problem began.

Picture 5.4 Box movie (8 yrs)

The first time that I met Kim's fifth grade teacher was on registration day. As I was going through my paces, informing the teacher of Kim's habits, phrases, and quirks, I caught a slightly puzzled look from her. I mentioned the fact that Kim had had some seizures in the past and, although it was not a present concern, I liked to keep a sharp eye on it. The teacher looked at me as though she didn't understand.

"You do know that Kim has autism, don't you?" I asked.

"No," she said, totally unconcerned.

I didn't expect her to jump up and pull her hair out or anything, but her reaction was totally nonchalant. I began to try to quickly fill her in. Then stopped.

"You mean they told you nothing? There was no inservice? No preparation? You haven't met with the autism specialist?"

She didn't seem to think that an autistic child would be different from anyone else. On one hand, that is an admirable quality; however, on the other, it's just plain naïve. I excused myself to go and meet Kim's case

manager who informed me that I didn't specifically address the inservice issue in the education plan. Therefore, it wasn't implemented. We had always included it in the past; I didn't realize it needed to be stated each and every year. At a meeting where I was not in attendance, the team felt that Kim had made such progress that we didn't need such preparation for the upcoming teacher (a cost-saving measure). This was going to be a year in which we would learn a great deal. Through many mis-steps and flat-out mistakes, all due to the lack of inservice and basic knowledge of autism, Kim was the one who suffered. One particular instance resulted in one of her most powerful pieces of work.

After a few written notes and communications from the teacher, the journal was abandoned altogether.

All of this was setting us up for failure. We weren't working as a team, sharing information, or making way for common goals. No one could see it coming. No one could have predicted that it would occur, and the only reason that I mention what happened as a consequence of the lack of communication is so that it may never happen again.

As I have said in the past, we had wonderful, well-meaning teachers. Several were proud of being a part of Kim's success while others were in denial that she had any special education issues. No matter what the case, all of the teachers and staff are bound by confidentiality rules. The law states that the information contained in the Individual Education Progam (IEP) is confidential.

I have always expressed, and still maintain, that the more information disseminated among the school *staff,* the more their understanding will stamp out ignorance. We have been open as a family about our daughter's autism, but we were always very careful when talking around her peers.

When Kim was in kindergarten, we asked the autism specialist when would be a good time to bring up the issue of autism with Kim. We didn't want it to become a label that she would rely on as a crutch or an excuse for not reaching as far as she could go. On the other hand, we didn't want it to be a sudden discovery or surprise.

The advice the specialist gave us was very sound. She said that, when we noticed Kim looking around her and wondering why she was different, we should tell her that we were glad she had noticed. Then we would sit down with her to share small portions of information that she could

process. The autism specialist also advocated that we use the word "autism" in her presence so that it wouldn't be so foreign to her. I was very comfortable with that plan of action.

Up to this time, Kim had not given us the impression that she was, in any way, feeling different from her peers, although they were becoming more aware of her quirks.

One day while I was approaching Kim's classroom to walk her home after school, the door opened and her classmates poured out of the room. As they passed me, they called out, "Mrs. Miller, did you know Kim is autistic?" I thought I had heard wrong, but a child tugged at my sleeve and said, "Kim is autistic."

I was horrified.

Kim finally came out of the room and unemotionally said, "Yes. I'm autistic." She was walking so quickly, I had to jog to catch up with her.

My first thought, "How did this happen?" was immediately followed by, "What is Kim feeling?"

At home, after settling her in with a cup of hot chocolate, I started making phone calls. It doesn't matter who thought up the plan or who was involved.

The school was proud of having a child like Kim: this was their first autistic student; people from the State Board of Education came to monitor the special education programs in our district; Kim's IEP of full classroom inclusion was selected by the school more than once to be reviewed; teachers, in anticipation of having an autistic student in their coming year's classroom, asked to come and observe Kim in the classroom environment; and, finally, the school was pleased with the contests she had won with her art skills. So, when someone saw a children's program that highlighted autism, they decided to tape it and show it to the class.

The fact that we, as a family, were left out of the decision to go forward with the plan was beyond heartbreaking. John and I were consumed with thoughts of possible repercussions for Kim. Kids can be cruel with a little knowledge and a lot of misunderstanding. Even if the children in the class didn't fully understand what autism was, they knew that she was different. They might not remember the word or what it meant, but they realized that Kim had been singled out and labeled. What really hurt the most was that we had been so careful to let Kim be who she was. We took our lead from her. She defined what it meant for her to have autism. Now I was

concerned that she would place limitations on herself just because of some definition of the disorder. There was a possibility that her peers, from that time forward, might see her as "the autistic girl" rather than their friend who was an artist and had a few quirks.

I was upset at the staff, and I was upset *for* them. No one intended to violate Kim's rights or to label her. I'm sure they just wanted to share what a special person she was and to share what might be possible for other people like her, and I truly feel that if this had been discussed—if we had been considered part of the team, if a presentation had been at least proposed in the journal—this violation of Kim's rights would never have occurred.

And Kim's rights *were* violated. The situation is basically the same as that of a physician who cannot divulge the fact that his patient has AIDS. No one in school is allowed to stand up, point a finger and say, "That's little Johnny, the kid with AIDS."

We knew the intent behind the action of showing the film was good, but there were certain agreements we would have to be assured of to try to right the wrong.

First, our main concern was to do whatever was necessary to help Kim. The staff reassured us that any discrimination issues that might come up as a result of this violation would be quashed by an informative inservice presentation by the autism specialist to the students. Second, teachers would be informed of the violation and would attend a meeting to cover confidentiality issues so that this would never happen to another family. Finally, I told them I was concerned that, because I "cried foul" and took this to the school district office, my resources for cooperation would dry up.

This year had been a prime example of how a successful, professional, and practiced team can fall apart when one person decides not to get involved. Our method of using the journal in dealing with the issues of Kim's autism had been put into place by professionals and had profited from several years of fine-tuning. It functioned well as a tool for collaboration on a single student but, in order to be successful, it was necessary for everyone involved to actively participate.

I write of this not to single out or embarrass any certain person or group, but I am hoping that, by relating the events, the mistake will not be repeated. I realize that, by placing Kim into a typical classroom, mistakes were bound to be made and unexpected things would happen. We were

moving into uncharted territory. The real tragedy would be for a child like her to be denied access to the classroom because of the liability of lawsuits. Our desire was to examine just what had happened and how it had happened, and to learn from the incident.

We put this event behind us and tried to move on. Kim seemed unaffected by the breach of confidentiality until about a year later when she began to process what had happened. She agonized over the fact that she was different or could be perceived as not normal. It took four years to put down on paper the hurt, the feelings of betrayal, the discovery of being autistic (see Picture 5.5).

Picture 5.5 Discovery (14 yrs)

MR. FIEND

In junior high school, Kim often complained about music class. One girl stared until it became too painful for Kim to look up or around. It was the first time that she had ever experienced hostility. She told me of students

whispering "retard" under their breath. I wasn't sure how I should advise her to handle it. She couldn't verbally dismiss them; her stilted speech would only make things worse, and, after a childhood experience of my own, I knew that ignoring a problem doesn't mean it will go away. But the bulk of Kim's grievances were about the teacher. Since it was only a semester class, I asked her to bide her time just a little longer until she wouldn't have to attend that class again.

In mid-October, we received Kim's first progress report. Just as we expected, it showed mostly As and Bs, but she wouldn't move her finger from the page as she was showing us. We assured her that the grade she covered was okay with us, no matter what it was, but, even though we didn't react to it, we were shocked to see an F in the column of grades. We pretended it was just like all of the other grades, but she was devastated. She has an incredible need for perfection, and now there was a blight, this grade she did not feel she deserved (see Picture 5.6).

Picture 5.6 Mr Fiend (13 yrs)

I tried to get to the bottom of the problem, which is like trying to look at a picture through several layers of gauze. Her answers to my inquiries were cryptic. After I had asked a number of questions from various sides of the problem, I ascertained that she was working in a group in music class on a particular project. Most of the members of the group were not motivated to complete the assignment. She had her portion completed but, because the project was not finished, the whole group received the same grade.

Marcia had come across this very issue in seventh grade two years earlier. At that time, when I pointed out that Marcia was a good student put into a group of less-motivated students, the teacher told me that she expected Marcia to influence the group into completing the assignment. Marcia was an outspoken, assertive girl who oftentimes took on the whole assignment of the group just to get it finished and in on time. Those peers often benefited from Marcia's sense of responsibility.

I understand the concept of putting children into groups to work on an assignment to team build, to break an assignment down into manageable pieces and work together for a common goal, and to, sometimes, inspire peers in academic or organizational skills along the way. However, this assignment was putting Kim at a severe disadvantage because she was not on equal social footing with the rest of children. This put her in a situation where she was destined to fail.

I emailed the music teacher, Mr. F, asked him if he had read the "get to know you" note that I had handed him less than a month ago, and wrote, "Her education program states that she should be placed with appropriate peer models when working in groups."

He wrote back stating there was a lot of time for her to make up for the extremely low grade, so her final grade would not be affected much. I forwarded his message to the autism specialist because I wanted to try to get a balanced view. I knew she would tell me if I was being unreasonable. The autism specialist knew, as I did, that Kim would always strive for perfection. It was the nature of her autism, and she had the same opinion as I did: it was not fair to her to have to work three times as hard to make up for a poor grade that she didn't deserve.

Kim was still having difficulty verbalizing what was bothering her. Deep down, I felt that she was experiencing feelings that may have stemmed from the emotional turmoil caused by the 9/11 terrorist attacks.

All of us had feelings that we couldn't put into words. However, when Kim's state of mind didn't improve, I began to think it was something I should check into. I set a videotape to play and did major distraction techniques to settle her thoughts.

As weeks went on, Kim's state of mind only got worse. One day she came home and announced that Mr. F., the music teacher, was lunging at her from his doorway in the hall. I explained that he was probably playing, but that didn't comfort her. All she saw from her perspective was that he was unpredictable, surprising her, and she didn't know what to do with this action. I figured it was a one-time thing, so I told her to get over it and relax; the day was over.

Day after day, she came home complaining bitterly about the music teacher whom she named Mr. Fiend. It was mid-November when she just wouldn't let it go. Kim has incredible recall. The only thing that we can truly know about the event that began this whole tailspin was in one particular drawing. One of those unpleasant memories from the prior year that she couldn't seem to get out of her head was when Mr. F. played a snare drum. The sound was excruciating to her. She clapped her hands over her ears, and I don't know if the students laughed at her or just what, but, to this day, she has not been able to clearly relate exactly what happened. The volume of drawings generated by this single subject shows that this was not just a passing problem. The teacher sensed that he was not in good standing with Kim, decided to try to relate to her, make her laugh, by lunging at her in the hallway. At first, Kim put her head down without giving eye contact, and then began to use her art portfolio as a shield. This only made him work harder for her attention, which only made the situation worse. She avoided that hallway altogether and then could not attend school at all. I had to work with a counselor at school to help the teacher understand certain concepts about Kim's autism. Had he read the note that I prepared for all of the teachers at the beginning of the year, this would not have been an issue. Kim was deeply affected by this event, although I believe she has now made peace with the unpleasant experience and continues to move forward.

Any time there was a question over whether or not the next year's teachers should receive inservice in autism, I brought out the vast

Picture 5.7 Loser (14 yrs)

collection of Kim's Mr. Fiend drawings (e.g. Picture 5.6). The time for the autism specialist instruction was granted.

Marcia asked me at the end of January if had noticed any of Kim's latest drawings (see picture 5.7).

"No," I said. "Why?"

"I think she's a little blue."

SCHOOL VIOLENCE

Kim's drawings were not hard to find. She always kept them at hand, neatly filed in a plastic portfolio. She had made a smooth transition to her new school, but she had suddenly been made aware that she was different. She would have to find out where she belonged. It hurt to watch her struggle without being able to facilitate or bridge some sort of friendship between Kim and these new children, but my daughter would have to find her own way.

Many rules and safeguards have been put into place due to the infamous school shootings in our home state as well as elsewhere in the United States, and, obviously, these rules have to be enforced for the safety of all the students.

One day, when I was a couple of minutes early in picking up the girls from school, the vice-principal, for whom I have the utmost respect, motioned me into her office. She said she had something very important to discuss with me. She told me straight out that a girl had come forward with some information that morning regarding Kim constructing a "death list." This wonderful, sensitive woman knew that my daughter was autistic and would be intimidated, distressed, and unable to answer questions if she were called into the office for questioning.

The law states that some course of action must be taken to deal with such an accusation. The vice-principal said that I should take my daughter home, get to the bottom of it, and phone her as soon as I knew what lay behind the accusation. We had such mutual respect that she knew she could trust me to be straight with her, and I knew I could depend on her to hold off notifying the authorities until we had found the root of the problem. I told her that I would look at the art portfolio, and I was sure it would soon give us the answer.

I quickly took Marcia aside and explained the situation. She knew how grave this was. When we sat Kim down in the living-room at home, we began to gently pepper her with questions:

"Have you made a list for Valentine's Day?"

"Did you make a party list?"

"Did you write names down on a paper?"

"I don't know!!" she said as she started to get frustrated, and we backed off for a minute.

While I was outwardly calm in looking over her sketches, I was frantic on the inside. "Thank God they didn't look at her drawings," I thought as I saw renditions of horror movies like Joan of Arc burned at the stake in the 3-D movie, *House of Wax*, (Picture 5.8), the guillotine with Marie Antoinette and the ever-popular hanging in *Frankenstein*.

After all the interrogation, Marcia and I were convinced that Kim didn't write down any list at all and, after we got through explaining why we were so tense, I don't think Kim will ever write down a list of names at school! She was upset to think that anyone would accuse her of such a thing.

I phoned the vice-principal and said, "There is nothing here."

She began to do some detective work on her side of the equation. In the afternoon of the next day, she phoned with an explanation. Kim had been upset in PE class, the first class of the day, and she was crying—who knows why? One child whispered to another child that Kim was mad and had made up a "death list." This was definitely fodder for the rumor mills, and how the wheels did turn. By the end of the day, a student who is usually responsible decided to report what she had heard and that set the whole episode in motion.

Obviously, a couple of students had found out that Kim was different and decided they could take advantage of that fact. The vice-principal was outraged that they chose a child who could not defend herself verbally, and she wanted to express to them the severity of their violation. She asked permission to talk to them about Kim's autism, but I felt that, because of their immaturity, they would just use it against her. This underlined for me the need for a social element in her education program. My daughter's drawings (e.g. Picture 5.9) could have been used against her at this point if the vice-principal had not been familiar with her autistic student and if we had not had such an open rapport.

Picture 5.8 Joan of Arc (13 yrs)

Picture 5.9 Horrors (13 yrs)

From the compilation of Kim's artwork thus far in this chapter, a person might get the impression that she did not care for school and least of all, her teachers. Nothing could be further from the truth. She loved going to school and enjoyed picking the teacher's brains for minute bits of trivia. She held the utmost respect for educators as her mentors and friends. Whether the teachers knew it or not, they were able to ignite inspiration. On one such occasion, an English teacher asked her students to write a poem. This was particularly challenging because, at that time, Kim found rhyming difficult and the rhythm of words didn't make sense. The teacher suggested a form of poetry that did not require the usual meter or word coupling. This sparked motivation rather than frustration. By combining her love of art and word imagery in literature, she wrote a lovely piece about "The Mime Who Speaks With Pictures" and, for added emphasis, illustrated it.

Mime

I am a mime who speaks with pictures
I wonder about the world
I hear the violin by a grave
I see Van Gogh's *Stary Night*
I want my fantasies to unwind
I am a mime who speaks with pictures

I pretend to be perfect
I feel as if being sculpted
I touch the invisable box
I worry that my dreams will never come true
I cry for being trapped
I am a mime who speaks with pictures

I understand I'm human
I say people are shallow
I dream of Paris
I try to travel there
I hope I get there
I am a mime who speaks with pictures.

I have found that Kim's ability to learn and overcome many barriers in her path was proportionate to the instructor's willingness to make modifications and accommodations.

Because autistic people learn from good peer or education models, it doesn't make sense to *not* support them toward a successful model/example. Because they do not learn from cause and effect, *it is vital* that a parent or educator be proactive to avoid the experience of continual failure. If an autistic person were to keep trying to problem solve with an unsuccessful template, they would continue to use that template and thereby erode their self-esteem with the sense of failure.

Oftentimes autistic individuals are perfectionists; barriers should be built into the program so that there are opportunities to problem solve in a supported environment. For example: Kim had problems understanding different tones on the phone. She couldn't distinguish between a dial tone

Picture 5.10 The mime (16 yrs)

or a busy signal or what they indicated. I set up a scenario whereby she would need help. Because I knew that she would be placing a call for me to pick her up from high school and that she would be using the phone in her counselor's office, I took my receiver off the hook at home so that she would receive a busy signal. I then left early so that I could watch the process through the window of the counselor's office in case I had to step in. The reason for this was two fold. I wanted to see if Kim would ask for help on interpretation of the sounds emitting from the phone. The other reason was to show others that my daughter still required some assistance in very basic skills. Many people who meet her are so impressed with how far she has come in her education program that they oftentimes forget that she has special needs. Some have even come so far as to begin to deny that she needs accommodations.

Education professionals along with parents working together can provide a successful formula for the child to use to overcome the obstacle that is holding up the learning process. By doing so, they are providing a variety of templates for the autistic person. The wider range of experiences with supported successful outcomes, the better chance that the autistic individual can learn to accept change.

For Kim, the ability to deal with abrupt changes in her schedule, people in her life, and her environment was not an overnight success. It took years of trying to remove the speed bumps of life. After getting the community, friends, family, and finally the education system all on the same road, we built a network of signs and directions for support where we could almost seamlessly guide Kim.

Chapter 6

Advocacy

Speaking on Kim's behalf or acting in her best interests seemed to be a never-ending job. After I visited my sister, the urgency to be a strong voice for my child became apparent. What I observed of Kim's behavior and what I knew of her autism were so very important to communicate.

THE POISONING

My sister Cami was gracious enough to not only open up her home to us but also to baby-sit while I was attending an autism workshop at the local college in the town where she lived. She reassured me that she would make an extreme effort to "Kim-proof" her home. Later that evening, back at my sister's house, I realized Kim had been out of my sight for a few minutes, so I went to find her. I walked into my niece's room. Kim was sitting on the floor with pink lotion on her hands and in her mouth. She was saying "ak-keem" over and over. I found the bottle, which, to my horror, contained a hair removal product. Quickly, I rushed to the phone and called "Poison Control," a non-profit agency that gives medical advice in the event that someone has ingested or been exposed to a poisonous agent.

I'd had occasion to call this number before when Marcia, as a toddler, had eaten part of an unfamiliar plant. They were very courteous, quick, and helpful with their information. If they feel the situation is serious, they instruct the caller in giving first aid and then advise seeking medical attention, but most cases are easily handled at home. The Poison Control center even calls back within the hour to make sure things are going well,

and again at two-hour intervals until the danger of any reaction is passed. I was confident they could assess the situation for me.

"Hello? Yes. I have a three-year-old who just swallowed a hair removal product—Nair®." I told them her weight and asked them what first-aid action I should take. They confirmed with me the name of the product and told me to wait. Meanwhile, my sister was trying to wipe out Kim's mouth with a wet cloth and to figure out where the Nair® had come from. She had carefully child-proofed her house and, besides, she didn't even use this product. Back on the phone, a woman's voice beckoned me to return my attention.

"Well, what should I do?"

"Nothing."

"Then I should take her to the hospital?"

"No, this product is so nasty tasting that no child, after smelling it, would get enough down to hurt anything."

I was horrified. This was the advice they would give for a typical child. I began to get a little rattled.

"Look," I said, "I have a three-year-old autistic child who *licked* this product off her fingers and called it 'ice cream.' Now, if you will, just tell me what I need to do to help her." I noted a dubious tone in the woman's voice as she gave me instructions on how to deal with Kim.

After the time of possible danger had passed, I had time to reflect. Would it always be this way? Would physicians and other professionals never understand—never take in the fact that autistic people are wired differently? If Kim and I were in a car accident and found unconscious, would they think she had a traumatic head injury because of her echolalia? How would they assess her if she did have an apparent head wound? Would they think she was not injured if she didn't react typically to a painful stimulus?

At that moment, it became clear to me that I was going to have to be the best witness and advocate of my daughter's health. I would have to translate her condition for any medical staff we'd have to deal with. I was going to have to be more assertive to express what I knew of my daughter's autism.

There were several levels to the job of being an advocate. There were the schools, health care professionals, community organizations, neighbors and family to deal with. I was concerned about tacking the

labels of "autism" and "disability" to my child. What good would it do to continually point out that Kim was different by using those terms? I had a feeling of reluctance at the pit of my stomach. When she received the diagnosis of autism, there was relief in giving a name to her symptoms, and yet I was very reticent to label her. Why would a parent want to do such a thing? It seemed that I was putting a cap on her ability to reach her highest potential by accepting the labels. As always, I consulted the Early Intervention specialists for guidance; I wanted to know all sides of the issue.

Mary, Kim's preschool teacher, explained that there are federal laws that protect people with disabilities from discrimination and affords them the right to an appropriate education. Because of her symptoms of autism, Kim would need modifications and accommodations to have the same opportunities as everyone else. The label of "autism" was vital because she would then receive services such as an autism specialist who would assist in developing an Individualized Education Program (IEP) specific to Kim's unique needs. Because the terms "disability" and "autism" were the key to laws regarding access to education, I embraced them whole-heartedly. The words were innocuous. The only one who would determine their meaning would be Kim. It didn't take anything away from her or make less than she was. The terms removed the barriers that stood between her and all she could be.

Without those laws, my ability to effectively advocate on behalf of my daughter would be much more difficult. There was empowerment in the word "disability".

Another situation where I believed that Kim would need an advocate would be at the preschool setting. I was concerned that she could not participate as an equal classmate because of her inability to verbalize her needs and because she was so passive.

Whenever Marcia took a toy away, Kim just acted as if the toy had never existed. I was concerned that, if the other children found they could take things away without any reaction or consequences, they would just take everything away from her. I voiced my concerns regarding her classmates at the preschool.

Mary said that, in those instances, an adult would step in and become Kim's voice. The adult might say, "I think Kim was playing with that toy." After giving the other child a chance to explain, the adult would try to

ascertain whether Kim was finished playing with the toy. The adult would also try to facilitate an interaction between the students. If the adult thought that Kim still wanted to play with the toy, she would try to get Kim to respond but, if Kim didn't say anything, the adult would be Kim's voice and ask for it back. If the adult thought that Kim was done with the toy, the same routine would be followed.

Even though she was able to verbalize at the age of four, most of her vocabulary was comprised of nouns. Her echolalia was mainly limited to phrases that had a tangential connection to pertinent subjects. Sign language still played a role in her communication, partially pantomiming the verbs she couldn't access in her utterances. When the neighbor kids came to play with Marcia, I often spent a lot of my time negotiating a part for Kim in a game or a play and even what kind of equipment she could use.

For years I advocated for Kim, always waiting for her to respond, and when she didn't I spoke for her, giving others my best guess of what she really wanted…until she started to draw.

USING HER ART

Every year our local fish hatchery opened its doors to host a free fishing day for people with disabilities. No fishing license or fees were required. Kim had just finished her third-grade year, her behavior was still unpredictable and often volatile, and we didn't normally try to take her on such an outing. It was a safety issue with the water, sharp fish hooks, and the fact that John and I alone were too few adults to provide adequate supervision. With so many volunteers at this event, it was a safe, controllable atmosphere in which to relax and have fun. The workers there were eager to assist the kids in the art of catching a fish.

Earlier, when Kim was four years old, she was ready to plunge into the water and grab one of those moving objects in the pond. I held her back while signing and saying, "fish" or "swim." Now we were counting fish, talking about the rules and expectations of the event. When the time came, the hatchery officials helped her get a fish on the line. After much fuss, the gentleman almost dropping the fish back into the pond and, galloping in the water after it, showed her the fish in the net. Expecting her to be

wide-eyed and smiling, he was a bit crestfallen. He asked her what she thought of her catch as it was wriggling. Kim peered into the net and stated in a flat voice, "My heart is beating." He glanced over at me and I assured him that she was thrilled. He looked a bit dubious as I gushed over what a beautiful fish it was while Kim hyperventilated and flapped. Obviously he had previously worked with children with special needs who were able to show their excitement and joy. Weeks later, we saw drawings of Kim happily fishing (e.g. Picture 6.1). I photocopied some of her work and sent them onto the hatchery as Kim's way of thanking them for such a good time.

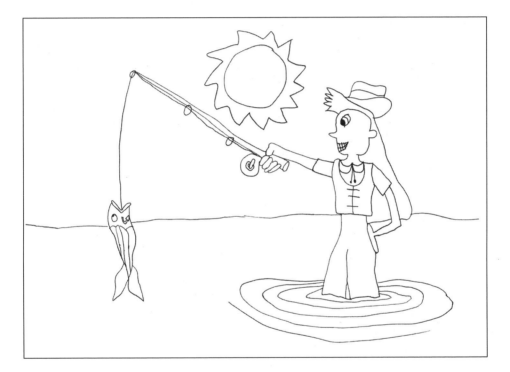

Picture 6.1 Fun fishing (10 yrs)

At first I used Kim's drawings to show that her intelligence and development were far beyond what the tests that she took were showing. As time went on, Kim's artwork revealed more and more of her thought processes. The teachers and staff could appreciate her playful way of participating in the group on paper. A good example of this was the way that she drew herself with a friend having bodies comprised of musical instruments (Picture 6.2). In fourth grade, she revealed that she understood our money

system by showing her dog, Louie, gathering donations dressed in a Boy Scout-type uniform (Picture 6.3). The sign on the cup states he is accepting donations of 50 cents. She shows two 25-cent coins which equals 50 cents, five 10-cent coins which equals 50 cents and finally a 50-cent piece. Having a tangible example in my hand, I used it as a tool to build support for Kim's ability to be an equal contributing class member.

Picture 6.2 My musical friend (8 yrs)

After leaving the preschool Early Intervention Program, it was important to meet together with public school educators, autism specialists, speech therapists, and child psychologists to work effectively on educational goals. The autism specialist was an incredible resource for the teachers, making observations and recommendations, and interpreting some of the puzzling autistic behavior in a practical way. All of us had ideas about how to guide Kim's educational path, but the most powerful way for her to be able to participate in the process was the communication in her own drawings.

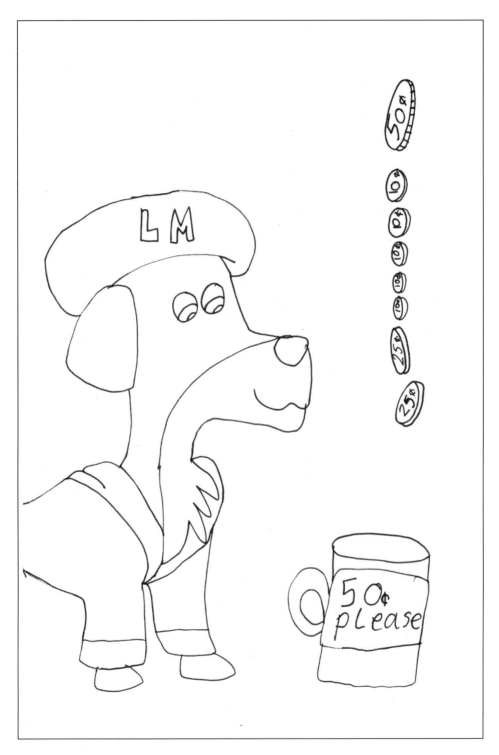

Picture 6.3 Making change (10 yrs)

It was important to inform the staff at school that her condition was not caused by environmental reasons. There was a healthy, supportive, nurturing family-oriented setting at home. Family upset or issues of a personal nature can sometimes sprout from or be aggravated by the nature of autism. We reassured the teachers with the lovely warm drawings that came from Kim's ever-growing collection (e.g. Picture 6.4). This was also vital because a drastic change in her work would certainly be a tale-tell sign of trouble. It was a type of barometer by which we could measure her emotional wellness.

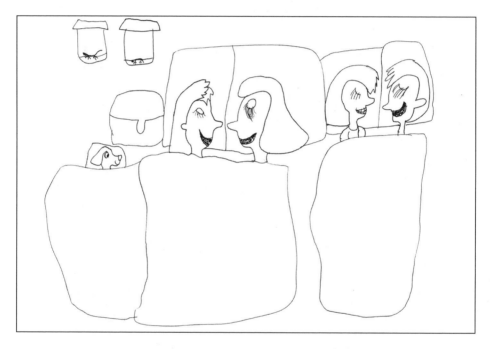

Picture 6.4 Family and friends (9 yrs)

As Kim's advocate, I had to be sensitive and careful not to make outrageous demands, or be militant or heavy handed with our suggestions. Teachers had a challenging job balancing the needs of the class and yet acknowledging the unique qualities of Kim's autism by making modifications. Because the preschool program was based on working with children and families, I was already accustomed to working with an educational team. Many of the public school staff were not prepared for the fact that Kim and I came together as a package deal. At first they didn't know what to think,

what role I would play in her education. When they learned that I actually lent support by reinforcing their lessons at home, and acted as Kim's interpreter and troubleshooter, they found that they could use me as a resource. As teachers voiced their concerns over concepts they felt that Kim was not absorbing, I often found the answers inadvertently in her work at home.

After the team was assembled, we had to make sure that everyone was of the same opinion regarding placement. (A typical classroom versus a self-contained special education classroom.) Some educators were of the opinion that Kim should be placed in a self-contained classroom and let out for short periods during the day for socialization. There was another part of the team that believed that she should at least have a chance to try inclusion where she would be educated in the same manner as her peers with modifications and accommodations.

By working with the school district representative, the hand of cooperation was tentatively extended. The recommendation for inclusion was based on the fact that Kim had "emerging" kindergarten skills. It was made perfectly clear that placement in the average school setting would be constantly re-evaluated. It was important for all of us to be unified in our vision of not only *how* her education plan should be delivered but of *where* as well.

When at last Kim was able to prove that she belonged in the typical classroom, we came together as a more solid team to make goals to support her education program. As a single unit, we could push from behind to not only support her goals but to continually move her forward. There were times when she reached her goals within six weeks; we had to call meetings and make new strategies. It was essential that all of the team members kept up to date on Kim's education program in order that we kept the momentum moving in a forward direction. At any time she could have a problem. When a regression or unexpected event occurred, Kim's behavior, self-esteem, ability to learn would sink like a rock. It took all of us to come together to get her to the functioning level she was at before.

If there were team members who were not of the same opinion, I would find out more about them and their philosophy of education, and try to pinpoint areas of common ground so we could relate to one another. There was always a chasm between parent and teacher. As a parent, I wanted educators to see the potential inside of Kim that I had come to know. On behalf of teachers, I had to acknowledge that they didn't have hours to

observe her to appreciate the intelligence that was so very slow in coming to the surface. If that didn't work, I brought out a portfolio of Kim's artwork; it seemed that no matter what our differences, educators could always make a connection there.

The transfer of information between home and school was so very vital to Kim's success. It was a delicate balance as what was happening in the home setting was affecting school life and visa versa. There was a team effort to contain stimulation in all settings. In order to achieve success in implementing strategies, a certain amount of trust and respect between us was required. Building a relationship of honesty without offending was tricky. I had to be delicate with egos. After all, these were seasoned professionals and I in turn had much to learn; for better or worse, they were my mentors. The most important point in working as a team was the fact that everyone who was a member was devoted to one thought only once they were committed—to focus on tailoring an education program to fit Kim's needs.

Each year the teams worked beautifully until it came time for transition to the next year's team. I was the only constant member of the team. It was like teaching a fresh group of people about Kim and her special needs. However, thankfully there were a few people who stayed in the same position over a number of years. The annual inservice became more effective each year as the scope of her world widened. There were more discoveries in her art, more to share, more to learn. Her former teachers were incredible assets. They had developed strategies and adaptations during the school year as they had "on the job training" with Kim. When an upcoming educator was a little unsure of taking on this challenging child, the previous teachers transferred their knowledge, experience, and confidence to their colleague. When the new teacher hit a snag, they were an excellent reference. Another way that the previous year's teacher was helpful in building support was to transfer the respect for me as a parent, an equal team member, fully prepared to be involved in shaping my daughter's education program. The educators of the past could testify to the boundaries (fears and quirks) that autism placed in shaping Kim's life. They wouldn't have to rely on the possible exaggeration or embellished version of an incident from the parent; it was far more believable from a colleague or separate source.

Nothing is more challenging for a parent than to have to earn respect and a reputation with one teacher only to have the slate wiped clean each year and start all over again. Many educators were sensitive to this and were generous in informing the future education team of my credentials. That opened the door so that I was more readily accepted as a valued team player.

MR. NEWMAN

One day in junior high school after attending a class that continued to be loud, day after day for over a week, Kim was overwhelmed. When I picked her up from school, she sat in my car and burst into tears. She said that the noise was so loud that "the air started coming out of my ears."

I didn't know what to think of this malady. I tried to question her further, which only caused her even more distress in relaying the event (see Picture 6.5).

She exclaimed, "Oh, great, now it is coming out of my eyes!" She cupped her hands to her face as though something would spill out. Many times overwhelming stimulation caused physical manifestations of illness or strange symptoms. She went to bed immediately when she got home.

Being Kim's advocate, I had to be very careful not to appear to be on the attack. Teachers often experience parents who are overprotective of their children. As a result, they can be a little defensive. I wanted to have a meeting to convey Kim's special needs, not my demand that something be done to control class noise. I contacted her speech therapist, Miss Sherrie, who had spent a lot of time with Kim in after-school sessions. She had witnessed Kim's condition after noisy days at school, and could confirm what I had to say. It was also important that I have someone from the education system so that there would be no appearance of ganging up on the teacher. Miss Sherrie called the meeting.

Mr. Newman was a large man with a voice that carried well when he became excited or passionate. Let's face it. Teenage kids are not quiet and, when a teacher has to use the command of their voice, it can get very loud quickly. Miss Sherrie invited both of us to talk over the situation. I quietly set out Kim's drawings on the table (e.g. Picture 6.5).

Picture 6.5 Agony! (15 yrs)

Mr. Newman was crushed; he had tried so earnestly to relate to Kim and he had done a good job. At first he thought we were there to criticize and change his teaching style. He kept saying that, after many years of teaching, he didn't know if he could change. On the contrary, Miss Sherrie and I were considering a modification to put into place so that Kim would

not have to bear the sounds that were so painful. We showed him some of the drawings that revealed what effect loud noises had upon her.

These were the strategies that we came up with:

1. Have Kim communicate to the teacher that the noise level in the room was approaching a critical state.

2. Seat her in the position closest to the door to allow her to slip quietly out of the room.

Picture 6.6 Mr. Newman (15 yrs)

Picture 6.7 Emotion in motion (16 yrs)

3. Allow her to leave the room at the point the noise became unbearable and to re-enter when it was over.

4. Give important instructions or assignments only while Kim was in the room.

It worked beautifully. Kim was in control of how much sound she had to bear, and Mr. Newman didn't need to change who he was or his style of teaching. He was much more aware of ambient noise. Whenever he needed to use the power of his voice, he warned Kim ahead of time. This collaboration led the way for Kim to take the first step towards self-advocacy.

High school was one of the easiest transitions that Kim would make in her education career. Because she has built such an incredible body of artwork and a reputation to match, the teachers and staff were primed and ready. They listened intently as I performed my usual inservice with her drawings (e.g. Pictures 6.7 and 6.8), taking in the stories and explanations. I stressed that the drawings may be true depictions of what happened or they may be her *perception* of what happened. It didn't really matter whether it was an impression or the accurate portrayal; what was important was they were getting a first-hand account, a look into the autism culture.

The teachers and staff had several questions regarding Kim's ability to process information, to stand up in front of the class to give a speech and to adequately keep up with her peers. I answered their questions by passing around the appropriate drawings. After eight years of collecting her work, there was plenty of material to show. They were particularly interested when it came time to show the passionate "Mr. Fiend" pictures.

There was never a shortage of material. The drawings grabbed their attention, each one of them determined to learn from the mis-steps of the past. The impression that I received from them was they wanted to be a part of Kim's education team; they couldn't wait for a chance to have her as a student. We agreed that, because she was coming into a new environment, she should have several tours of the school and say a face-to-face hello with the staff. Since we had laid the groundwork a month before school started, the rooms were deserted. On our rounds, we popped our heads into classrooms. As chance would have it, one math teacher, Mr. C., was preparing his computer for lessons. He greeted us warmly and actually took us on a small tour of his own. We met him a few more times on our

Picture 6.8 Final face off (15 yrs)

walkabout. Each time he had an inquisitive question to draw Kim out and asked her observations of the school. He was artfully investing small segments of time to establish a relationship with Kim. Little did he know, the time would come when he was really going to have to bank on it.

Using Kim's foundation of art, Mr. C. connected art with mathematical correlations such as fractals and tessellations cementing a relationship of mutual respect and trust.

Everything was going very well for months into the school year; then it happened. Kim was doing alright on the homework assignments, but had scored poorly on tests. One main reason was the restless noise of students' bodies during testing. Because of the ambient sounds and the lack of ability to concentrate, there was not enough time for her to complete the work. It took her longer to process the information. When she saw her grade on her report card, she took to my bed; her self-esteem was so low at this point.

The sight of the grade was the problem in her mind; the perfectionist side of her couldn't overcome it. She was accustomed to earning straight

A's in junior high school. It was just not acceptable for her to receive a low grade. Mr. C. phoned me and told me what the situation was. I wasn't sure how they were going work this out between them.

Kim told me that she didn't think she was going to be able physically to walk into his class. I passed on this bit of news to him. He waited near the

Picture 6.9 Exhaling beauty (19 yrs)

Picture 6.10 Finding my niche (19 yrs)

door the next day, took her aside and told her that she wouldn't be receiving a grade in his class for this quarter. Mr. C. had just removed her mental impediment to entering the classroom environment.

"What is important, is what you learn in my class."

He then informed Kim that he was going to give her three mathematical problems on one page as opposed to the 30 the class received for homework each day. When she mastered those, he would increase her load. There was no doubt this was to build her self-confidence once again. Within a week he had her at grade level again, tentatively doing the work. He asked her what she needed in order to do better on tests. After she told him about the noise, they both agreed that the opened door area in an adjacent filing room would work well and she would receive extra time on tests. They sat down and worked out the details between the two of them. Kim felt comfortable enough to advocate for herself.

When Kim left the high school after finishing her final semester, I had a chance meeting with some of the education professional friends who had been steadfast in their support of the inclusion vision.

I took advantage of the situation to ask why Kim was afforded the opportunity to be educated along with her typical peers. The answer was mainly because of her ability to express feelings, wants, needs and intellectual development through her art (e.g. Pictures 6.9 and 6.10). In addition, my determination to utilize this gift on her behalf, and to advocate for the least restrictive environment possible with autism support, were the keys to working successfully with the goal-planning team to ensure consistency throughout her educational career.

Chapter 7

Perception

During the late 1980s, there were all kinds of articles about autistic children regarding "being in their own world" and "unreachable." Unfortunately, these writings often offered no hope of being able to permeate the shell of an autistic child. The perception of these rare and unusual individuals was finally being published and the public made more aware of the disorder. Autism was not a spectrum disorder at this point. The criteria were very stringent and specific. Many children did not meet the standards for autism, either because of the mildness of the disorder or because the individual did not have deficits in all of the specific areas. Those children were labeled "learning disabled." When a student received the diagnosis, the lack of understanding was profound. Most people found it difficult to pronounce the word properly and often mistook it for the word "artistic." There was just not enough published information disseminated at that time for the everyday individual to relate to autism.

KIM'S PERCEPTION OF PEOPLE AND ENVIRONMENT

It was often difficult to gauge or predict how my daughter might react to any given situation or person. I didn't understand why she flung her head backwards and stiffened her body for no apparent reason. Everything around her appeared to frighten her. Ordinary everyday objects, people passing by on the sidewalk, people in the stores—all made her frantic and at times withdrawn.

Without proper preparation and foundation to communicate to Kim the places we were going, she was reluctant to get into the car. Once outside the car, while trying to find the entrance to the building, she would find a crack in the sidewalk fascinating and it was then almost impossible to get her to focus on anything else.

PEOPLE'S PERCEPTIONS OF HER BEHAVIOR

Often I would catch strangers, comparing Kim with their child—not out loud, but with a glance. They were assessing her development and behavior. I could see the unspoken questions forming in their eyes. Why was she not talking, asking a myriad of questions like those her age? What *was* her age? Was she mentally slow? Her demeanor was so aloof and quiet; was she abused? Many times, when she was throwing tantrums from frustration, the looks telegraphed a message quite clearly: what this child needed was some discipline!

Even though the mothers in the Early Intervention Program were beginning to accept us, it was hard for me to get to know them because Kim required my attention all the time. During our sessions together, I was busily getting her out of equipment and drawers she shouldn't be in to. Her habit of trying to escape the room often had me in the role of guarding the door; there just wasn't time for conversation. However, the mothers were friendly and warm, inviting us to meet them at the park or come to their houses for play dates. I always declined the invitations. Even though I had the freedom in my schedule to visit them, it exhausted me to take Kim to the park because of the wide-open space; she was constantly on the run. And under no circumstances did I want to go to someone's house only to have Kim dash something precious and breakable to the floor. Their houses just weren't Kim-proofed. I could almost guarantee that.

Cindy, the outspoken one of the bunch, was getting tired of my excuses. One afternoon, she phoned me and asked why we wouldn't join them. I said she had seen for herself how Kim acted, but Cindy assured me that it would be okay and that all the other mothers would help watch Kim. With much apprehension on my part, we showed up on Cindy's doorstep.

Kim played within the vicinity of Cindy's little girl. We had been attending classes for a few months now, and Kim was getting accustomed to her new classmate.

Kim didn't interact as other children do when playing with their peers. It wasn't that she didn't share the toys. It was more like she was playing her own game, one that never required the reciprocation of another. She played side by side with a peer but was only aware of the game she was focused on. This behavior is called "parallel play." She never indicated any displeasure if another child took a toy she was playing with. She just acted as though she'd never had it in the first place.

After handing me a cup of coffee, Cindy and I watched the children play. I felt tense, ready to disarm Kim of anything valuable that she might latch on to. Even though the surroundings were new, she seemed to be content to stay, which gave us an opportunity to talk. Because our lives were unpredictable with the special needs of our children, another mother who had been invited couldn't join us, so it was just Cindy and me.

Cindy and I talked about everything—our homes, our families, and how we came to be in our situations. Seemingly out of nowhere, Cindy asked, "Do you spank Kim?"

I was startled by her frankness. I told her no and went on to explain to her that just using the word "no" sent Kim into a fit for hours.

"Do you mind if I do?" Cindy asked, "I'll do it lightly."

I weighed it in my mind. I didn't like the idea of swatting Kim for no reason, yet I needed someone, just one person, to understand. I was really considering it, but I didn't want to do it for the wrong reason. I wanted to make it perfectly clear to myself that my motivation for allowing this was not just for the approval of a new friend. After a couple of moments, I gave consent.

Cindy led Kim over to a chair and instructed her to sit down. She told Kim that she must stay there and, if she didn't obey, she would be spanked. Kim immediately popped off the chair like a cork shot out of a bottle. Cindy took her hand and placed her back onto the chair, all the while telling her of the expectations. As soon as Cindy let her go, Kim was off and running. Cindy caught her and held her for a moment. She told Kim why she was getting a spanking, gave her a light firm pat on the bottom of her padded diaper, and turned her loose.

Kim immediately lifted her small hand up to her face and looked from her hand to her bottom. Then she patted her butt firmly and examined her hand again, all the while turning in a circle, like a puppy chasing its tail. Over and over, she spanked herself, each time trying to figure out what it meant. The cause and effect was lost on Kim.

Finally, Cindy distracted her with a cookie. "I'm sorry," she said in a low voice. She asked what strategy the special education team had come up with and where could we take her to get more help. I told her that, because autism was not diagnosed with a definitive medical test such as an x-ray or blood test, the Early Intervention Program, at that time, was the only place that could help us with the answers. From then on, Cindy was one of Kim's greatest advocates.

COMMUNITY RESPONSE

We weren't welcomed in every setting of our small town with open arms. As a very young child, Kim did not possess the self-control it takes to override the many compulsions and behaviors that autism presents. Once, while sitting quietly at a taco stand, a busload of teenagers came in boisterously. As the noise level began to rise, Kim started to react. She was so stiff that I had to carry her like a wooden log. It was crowded and difficult to make our way to the door. Marcia knew exactly what to do as she pushed her way through the crowd, anticipating our exit.

We were almost at the open door when Kim let out a screech. One student, startled by the sound, started yelling at Kim. For the first time in my life, I screamed back, "She's autistic, okay? She can't help it!" Then we exited. I realized that the teenager had no idea what was going on, but I was beginning to get defensive about strangers' interpretations of Kim's behavior.

It was always hard to wait in line in a grocery store, or anywhere else for that matter. Since Kim had no concept of time, she would try to sit or lie down on the floor every few minutes. After a while she might begin to throw a tantrum. As we wrestled our way to the counter, many times I just tossed my checkbook to the clerk and yelled over the commotion for him or her to please fill out the check so I could sign it. While signing my name,

I would say something like, "She can't help it. She's autistic." The clerks, usually with a wild look in their eyes, would ask what that was, but, by that time, we'd be halfway to the door.

While sitting in the preschool room one day, Mary asked me what my greatest fear for Kim, aside from safety concerns, would be. Without hesitation, I answered that my fear was of our community rejecting Kim because they didn't understand her. I didn't want people to point at her and discriminate against her because she might talk to herself or flap in public. I wanted her to be an accepted member of the community.

It was at this time that Mary gave me the best advice. She told me to talk to people about Kim, to let them get to know her through me. I didn't know who to start with, but she suggested that I tell just a few people at first.

During Kim's kindergarten year, the local arts guild approached me about featuring her work in her own show at the time of the annual arts festival. At this point there were countless articles about autism. Most people in the community were familiar with the stories of autism that included the words "withdrawn" and "in their own world." Even though autistic individuals were coming out with their personal stories, information was slow in coming. This was a prime opportunity to demystify at least one person affected by this disorder. I thought that it was a good idea because her drawings could reveal to the public that people with autism can express ideas, can show nurturing relationships, and can be imaginative or playful, despite a stoic expression. We were very excited about the chance to show a positive side to autism.

After hanging the work and giving interviews to the local media, we were ready. The turnout of people was most encouraging; however, they failed to see the significance of the work. It was apparent that they were viewing the artwork as though they were just a typical small child's drawings, like something a person might see posted on the refrigerator in anyone's home. However, would their kindergartener have added highlights to the balloons or added such a small detail such as a lemon slice in the water glass (see Picture 7.1)?

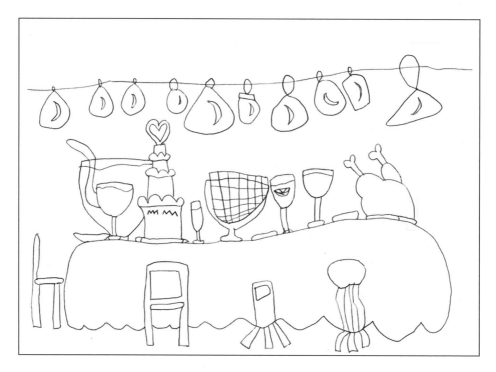

Picture 7.1 Parties (6 yrs)

The average person did not know enough about autism to truly grasp the significance of the kindergartener's scrawls. They didn't know that Kim was extremely fearful of people and that the irony of her art was that she chose to draw the human face and figure. She also drew lavish parties with heaps of food (e.g. Picture 7.2) when, in actual life, she couldn't bear to attend or partake.

Those in attendance couldn't appreciate the fact that these drawings were depicted with the expression of emotion from a child who rarely smiled or expressed feelings outwardly. Drawings that showed friendships and people touching one another (e.g. Picture 7.3) all developed from a girl who found it tactilely painful to hold hands with her mother and father. She could join in a game with classmates on paper, when the truth was, in real life, she played in a parallel manner beside them. Just from a developmental or artistic standpoint, the fact that a kindergartener could draw three-dimensionally was very significant. It was obvious that there needed to be more preparation and education regarding autism before others could understand or appreciate the value in Kim's drawings.

Picture 7.2 Food-laden tables (6 yrs)

Picture 7.3 Scouting friends (10 yrs)

CHURCH

Many of the symptoms of autism are, in many cultures, thought to be indicative of some inherent evil. By taking the more dramatic stereotypical behaviors out of context, anyone could mistake self-abusive conduct, self-stimulatory behavior (stimming) such as flapping, and tactile hypersensitivity as some sort of demonic manifestation. This focus on just a few characteristics of autism and not the totality of the disorder can put a person at risk of "cures" that are quite dangerous. All of this stems from lack of education and understanding of the complexity of this condition, which adds to its mystique.

When Kim was diagnosed, we wondered how society would view her autism. The symptoms of her autism were easily misunderstood by store clerks, fellow shoppers, and our basic community.

We belonged to a small neighborhood church that we had attended since John and I were first married. Everyone there grew familiar with us and then, as we added to our family, with Marcia.

Marcia fit right into the expectations of the church. Although she was quite lively, she behaved like an average child, in an appropriate manner, but, after Kim came along, we seemed to evaporate from the services. I couldn't take her to the meetings while she screamed and, most of the time, she couldn't be comforted.

When a friend invited me to a special meeting, during the week, where mothers of preschoolers got together for the express purpose of getting out and having adult conversation, I thought I had found a solution. That particular church provided baby-sitting upstairs while the mothers gathered in the basement to have refreshments, craft time, and a good gab session. However, after three sessions, I was told that, although Marcia was more than welcome, I would have to make other arrangements for Kim. She was upsetting all the other children with her inconsolable crying.

Kim stayed in the nursery in our church far longer than her peers because she wasn't toilet trained, a prerequisite for graduating into the two- and three-year-olds' group, and, finally, one of the nursery attendants, a dear elderly lady, took me aside and said that Kim could no longer remain in the nursery. She said it was too dangerous for the infants. When I looked at her in shock, she explained that Kim was tall enough to reach items that

were put out of the babies' reach. Some of the things she got into had parts that the little ones could choke on, and sometimes she tried to empty out the diaper bags, which caused the attendants a lot of work and worry. I understood her point, and I had, however reluctantly, to agree.

After that, I sat with Kim in the back row of the church hoping to hear some part of the sermons. To keep Kim from screeching or howling, I had to stay constantly in motion, bouncing, rocking, and swaying to keep her quiet. She particularly liked me to lower her gently backwards, slowly letting her head touch my ankles and then, cradling her head, lift her to face me again.

During that time, I was really tired from lack of sleep and, by the end of the services, I'd be exhausted. My thoughts and focus were so disjointed that it had been difficult to concentrate, and sometimes I wondered why I tried to attend at all. I knew that my faith would not suffer from lack of attendance; I was engaged in an ongoing conversation with God just to get through the day, anyway. The main reason I was there was to give Marcia the chance to enjoy Sunday school with children her own age. It was one hour when she could be free of the usual family cares and take pleasure in learning about our faith, but there were countless times when we were all dressed to go and never made it because it was just too stressful for Kim. She was over-stimulated and reacted with frustration, throwing tantrums, biting her hands, and slapping her face. She was extremely combative and I began to wonder how long I was going to be able to control her behavior so that she wouldn't hurt herself or anyone else.

For a string of Sundays, it became increasingly difficult to get Kim near the church, let alone enter it. As soon as we parked our car, and she got a good look of the cross on the building, she'd begin to react—writhing and flailing, kicking and screaming. I would get her calmed down so I could carry her into the building, where she was again terrified by the large portrait of Jesus on the wall—more writhing, flailing, kicking, and screaming—and I'd rush to a different room where she could get herself together. This was Kim's typical response to our churchgoing for about four months.

Finally, a woman, trying to help, came into the room to talk with us. She sweetly asked me what I thought the problem was. I told her that Kim seemed extremely afraid of something.

"Well, you know fear doesn't come from God," she said, "It's not the fruit of His spirit. And we all know where fear and anxiety come from..." She was convinced that the signs that Kim displayed were from Satan. She thought Kim was possessed or at least influenced by some evil.

Now, I knew that not all of the parishioners shared this opinion, but it hurt to think that even one did. However, we kept coming, Sunday after Sunday, struggling and praying. One day, we knew it would get better. It had to.

Kim was nearly four before she was able to attend a small gathering of children in a fellowship room where the kids were allowed to play and sing while parents attended the worship service. A couple of elderly women were in charge of managing the group of children, whose ages ranged from 2 to 11 years old, and they did a fine job of it. However, with Kim in the mix, the job became impossible.

Twice, while I was able to attend the worship service, one of the ladies tapped me on the arm and whispered, "Kim's gone." The first time, I bolted out of my seat and they rushed me to the foyer where they explained that all the children had looked for her in the church, but could not find her. I ran out of the door in a panic, not knowing where to look first, as Marcia came around the corner holding Kim by the hand.

I knew it was difficult for the ladies to keep track of Kim. In any room, she went from door to door trying the doorknobs over and over, testing to see which one might be unlocked. Success was only a matter of circumstance and time, and these poor ladies didn't have the experience to handle a child like Kim. After the second escape, one of the ladies suggested, with a pained look, that perhaps I should keep Kim with me. They just didn't have the skills or training to look after an autistic child.

After Kim was diagnosed, attitudes and understandings changed for us. Although very few people knew what it meant to be autistic, one far-sighted Sunday school teacher arranged for the autism specialist to give a small talk on autism and to answer any inquiries. Much to my surprise, over 20 people—not just teachers, but also friends—attended with questions in hand:

"Could we expect to promote her along with the other children?"

"Will she be able to participate in little plays?"

"Is this a lifelong condition?"

"Will she improve?"

"Will she be able to understand the concept of God?"

When we finished the session, the autism specialist turned to me and said, "You have a great group here. They really care." It was one of the best ways that we could educate them about Kim's challenges and what were the expectations. They asked candid questions regarding their fears or apprehensions. Never again did I hear any suggestion of Kim's behaviors stemming from a source of evil.

Because of the inservice that was given by the autism specialist, church members were more understanding. No longer did they approach Kim with their arms wide-stretched to try to give her a hug. They now spoke in low unexcited tones when they addressed her and tried not to overwhelm her with touching. This was especially difficult for some in this very demonstrative and friendly bunch, but they realized that any improvement with Kim was not going to be accomplished in a day, and they accepted what she could give. Because the people of the church were more sensitive to the fact that eye contact was painful for her, they did not get down to her eye level and vie for her attention. Nor did they leap to the conclusion that her lack of solid eye contact could be attributed to any type of shiftiness or unworthy character.

The people at that meeting listened with open hearts and open minds. Because of the information they received, they did not question the source of her stereotypical behaviors and that her tantrums were borne of frustration and the inability to communicate. They gave us room and time to grow without projecting a judgment or stigma. It was at this time that I realized just how important a small grain of information could be. These people did not need a three-hour seminar on the finer points of autism; it was a short meeting that answered any questions and addressed any concerns they may have had about Kim's seemingly bizarre behavior. Soon they were able to relate to her as a typical child who just had the symptoms of autism.

The church showed their concern by purchasing a small gate to go across a doorway so that Kim could attend a classroom by the age of four and a half. However, there were still issues about keeping her out of supplies and not climbing up walls. This is not to say that there weren't still some problems along the way in our church life, but just these simple, comparatively small things made a huge difference in our lives. The little bit of information from the inservice went a long way.

A new minister named Lee came to our church. As he introduced himself to us, it was too stimulating and Kim went into a seizure. Lee saw us fleetingly a few times over the next several weeks and then, when we had a quiet moment, Kim and I visited him at his office. I felt it was important for him to meet her in a calm state, After all, it wasn't fair to her, the impression we left him with of our last encounter. Lee was relaxed and quiet as Kim examined everything in the room. He listened to what I had to say regarding her autism and asked several questions. During the meeting, I complained that I couldn't supply enough paper to satisfy Kim's current need to draw. I explained that life was a little easier when she was able to express herself through drawings and, consequently, her behavior calmed down.

About two weeks later, Lee showed up on our doorstep with a box of paper. His wife, he explained, worked in a medical office with a printer that used continuous feed paper with perforations between the sheets. This system could be very wasteful of paper because it left a blank sheet in between the pages of patient information. These blank sheets were usually thrown away, but Lee's wife asked the company if she could have them. She made sure the pages were truly blank and contained no confidential information, and, from then on, every two or three weeks, Lee would bring Kim a new stack of paper.

The church office people did not understand the significance of the paper until Lee started his "paper for Kim" campaign. He directed his staff to get the paper. If Kim was having a particularly difficult time, sometimes we placed an emergency call to the church office, where they would scramble around for every scrap of recycled paper they could find. During that call, they might hear Kim in the background screeching, "Paper! Paper!"

In the beginning, we had no assurances that she would have the ability to comprehend the embodiment of faith, God, or religion. Because it was difficult for her to connect even with the physical world around her, how would she find her way in the spiritual one?

After attending an annual Christian summer camp in high school, she began make sense of these concepts, integrating the abstract thought with the concrete image. If she couldn't touch or see God, she would develop what she knew of Him, on paper.

Picture 7.4 In God's image (15 yrs)

Picture 7.5 Candle-lit prayer (16 yrs)

Picture 7.6 Repentance (15 yrs)

In the drawing entitled, "In God's image," (Picture 7.4) Kim's interpretation of God is very personal. A quill pen is being used to fill in the moles that make her distinctly herself. In all of Kim's drawings, she includes those little moles—identifying marks that make each of us individuals. Such a tender gesture, so touching to see that she knows she was carefully and purposefully, with undivided attention, made.

Picture 7.5, "Candle-lit prayer," has a spiritual theme. The drawing is of a person praying or meditating; her head, which is a candle, is melting in multi-colors. Kim's explanation is, "Kind of a flaming inspiration. God brings out our beauty from inside." Referring to the black and white portion, she says that it's just us, "being ourselves."

What I understand her to say is that our flame is like a prayer to God. He gives us inspiration. As the wax melts—a result of spending time in prayer—He brings out our beauty from inside. We are otherwise colorless.

The third and final sketch (Picture 7.6) is Kim showing us that she understands what repentance and baptism mean. She says goodbye to her sinful self and begins a new life. Although Kim doesn't verbally tell us everything that she understands, we find comfort in her direct communication with this sketch.

Even though people might not understand a situation or even be able to comprehend the struggle, small kindnesses mean so much. If Lee had not tried to help in the only way he knew how, Kim might not be the artist that she is today. He allowed God to use him for what may have seemed to some like an almost insignificant act.

BECOMING A MEMBER OF THE COMMUNITY

Another person to whom I mentioned Kim's autism was my hairdresser named Carson. He made casual conversation as he washed and cut my hair. In between time, I talked on about my four-year-old daughter's special needs and the talent she possessed as an artist. Every time that I went in, I told him a little more until he too understood the unique challenges for Kim. He urged me to bring her in, but at that time she was resistant to being touched or meeting strangers. Finally after several years, the day came when she actually sat in his chair as a teenager and allowed him to cut her

hair. He knew so much about her by then that he realized what a momentous occasion that was.

Carson asked for updates about Kim in between visits as I proudly showed several drawings to him. In the meantime, her artwork developed and he offered to hang some of the sketches and paintings in his shop. People from the nearby area came in to have their hair done and would often remark about the artwork. It was in this positive way that the community came to know Kim indirectly and without prejudice. People began to view her as someone creative rather than as a child who was highly-strung and willful. They responded to the communication and beauty in her drawings (Picture 7.7). Through their curiosity about the artwork, they could then be open to taking in information about autism. When we bumped into people at the store, they acknowledged that they had enjoyed seeing Kim's art at the hair studio. Whether Carson knew it or not, he was building a positive relationship between Kim and the community.

Many of the children who had attended elementary school with Kim came to know her as a gifted artist and a funny friend. As she made the transition from junior high to high school, she had to re-establish her place or rank in the minds of her peers. She gained the respect of the other students when her artwork was featured time and again in the display case at school. When she received recognition from the Autism Society of Oregon Walkathon as the designer of the 2005 T-shirt (Picture 7.8), she shared the news only with the staff at school.

Most of Kim's classmates thought that English was her second language, because her manner of speaking was so stilted, and they often asked the teachers if she was a foreign exchange student. They could see that she was able to function in the classroom, so they ruled out the possibility of her having a disability. As a matter of fact, she often offered answers to many of the open-ended questions that teachers posed in order to generate classroom discussions. So it came as a surprise when Kim decided it was finally time to reveal to her peers why she was the way she was.

She was apprehensive not knowing how the other classmates would behave towards her after making the announcement, the sting of the fifth grade incident hovering in the back of her mind. She had witnessed

Picture 7.7 Untitled (19 yrs)

Picture 7.8 2005 Oregon Walkathon design
(16 yrs)

students with special needs being treated poorly and held up to ridicule. Kim widened her circle of support as she decided to give interviews to the local television stations in the area. I had been her advocate for a very long

Picture 7.9 Untitled (13 yrs)

time, but as a teenager in high school she decided it was time for her participation. April is National Autism Awareness month in the United States. In her senior year, she consented to tell of her autism and ability to the school newspaper. She gave the interview and I was there to offer any language or context gaps. When the paper was printed, we were surprised by the positive comments, encouragement, and acceptance Kim received. The

Picture 7.10 Untitled (17 yrs)

clay sculptures (Picture 7.9 and 7.10) are a good sample of some of the pieces that were on display in the showcases during junior high and high school. It was through these sculptures and works of art that her fellow students saw her talent and ability to express herself. The girl that they knew was very reserved and many times did not return a wave of the hand, a greeting, or sometimes even eye contact. Here in the glass-shelved cases they saw a side of her that they never knew.

Kim became known in our small society as an artist first and then an individual with special needs afterward. People were interested in the stories behind the pictures, a type of portal to the other side of a place or culture where they could not go and did not understand.

Chapter 8

Relationships

The most important part of the word "relationship" is the root word "relation." Not only does it refer to kinship and bloodline but also to an alliance and interdependence. I tend to think of it in terms of mutual love and respect.

When we first learned of Kim's autism, the question of whether she could have an emotional attachment to anyone in the family was at the forefront of our minds. The thought of our living like polite strangers in the same house was a notion I could not bear. The most important things in my life are family and friends and our connection to one another. Could we laugh, cry, and play together? It didn't matter if she could not speak or read; I wanted her to share our lives.

One of the first issues was in trying to communicate. After that was established, a great burden was lifted from our shoulders, but how were we going to teach her to love and care for us as we did her? These were such intangible qualities, which seemed to be impossible to convey.

MAKING A CONNECTION

In order to have a relationship, a person must have a sense of self, an establishment of an ego. In the beginning, it seemed that Kim did not ask for anything on behalf of herself; she never argued a point or tried to use any type of persuasion to sway opinion in her favor. Even as youngsters, most children whine and wheedle to let their will be known or even to manipulate others to change their minds. Somehow they believe, because of who

they are, their rank or position in the family, that there is some sort of power to pull the heartstrings of another.

Many children with autism are compliant, quiet, and affectionate, although they struggle with the complexities of the disorder. The characteristics of autism that encompassed Kim were so difficult and overwhelming to our small family that immediately after she was diagnosed we had to resist the urge to medicate her behavior. She threw tantrums, bit her hands and slapped her face, behaviors caused by her constant frustration. Her body was in continual motion. As I sat in our living room 20 feet away, the window would shake from the activity in Kim's adjacent bedroom.

Because she had a sleep disturbance pattern and did not really sleep through the night until kindergarten age, and even then only 70 percent of the time, it was tempting to want to make our situation better. One important question we had to ask ourselves was: Would we be using the medication to benefit Kim or relieve the stress on ourselves? A mother of a child with a different disability explained her reasons for not medicating her child. She said that even though there were drugs strong enough to control the debilitating symptoms of her daughter's disorder, there was the possibility that they could suppress her child's ability to learn. After finding out more about the various side effects of strong medicines that promised to cut down on abusive behaviors, or at least calm down Kim's external appearance, we gave the thought long and strong consideration. Even typical children are difficult to treat because of their fine chemical balance; autistic children's chemical imbalance makes accurate treatment even more difficult. It's like, if you are driving a car and it gets slightly off-course, you don't want to overcorrect because that could cause even bigger problems. In most cases, it is hard to determine whether the behaviors are extreme enough to warrant the issues of medicating a child. As a result, we weighed the decision of medicating Kim very carefully and opted against it. We chose other means to deal with stereotypical behaviors.

Being a family in the context of autism is certainly a challenge. To be a functional household, everyone must work together toward the good of the unit.

We had such a small amount of time to spend with Marcia, and even less together, that it was hard to maintain a united front. We were

imperfect—human and passionate—about what was best for Kim and for us as a family. There were many years of growing pains. All of the theories on how to handle a disorder like autism with all of the accompanying symptoms of perseveration, inability to communicate, overwhelming sensitivity, puzzling rituals, and self-abusive behaviors were just theories. Nothing was absolute; there was no formula that promised success. Even after you manage to extinguish an unwanted behavior, it may flare up again or, sometimes worse, another difficult behavior may take its place.

Autism isn't just one behavior or another; it's everything. It seeps into every cell that makes up that complex human being. It can't be separated from the person. In many cases, assistive technology can be used to minimize the effects of physically handicapping conditions, thereby allowing a person to overcome the disabling attributes, but there is no machine to compensate for an inability to perceive accurately or a lack of intuition. Autism, although not physically apparent, is still a disorder—not just a behavior problem.

The family of an individual with autism have to be flexible and to stand against the norm—to be willing to expose themselves even if it may cause embarrassment. We had to realize that the chance existed that none of the behavior strategies we had read about would work for Kim. We had to be prepared to accept that she might never get better, never be able to show her love, never be able to share her thoughts and feelings with us.

The strain of this knowledge was testing our limits of patience, our understanding, and the dynamics of our family roles. We pushed against the current of the norm. We didn't expect to be a picture perfect family, but we wanted a family life where everyone was comfortable in their roles. Because of Kim's regressions, all of our progress toward establishing that family life felt like we were plodding up a hill and then being pulled back down into roles we didn't want. Sometimes it seemed that we had not gained any ground at all, and there was nothing—no book, no specialist, no authority—that could tell us where the next step should be.

The family is all about relationships, social skills, personalities…giving, taking, and love and forgiveness, which is a real challenge for an individual with autism. Family members make adjustments for the foibles of others and hope the same grace will be applied to them. All of

these intangible concepts are lost on a person who relates to objects more readily than people.

REJECTING JOHN

As I mentioned before, the relationship between John and Kim was strained. Whenever he came around her, she tucked her head tightly into my shoulder. She appeared to be scared of him for whatever reason. For the first six months of her life, he really didn't have a good look at her.

Daily living at home was a little rough between all of Kim's screeching and wakefulness. Unfortunately, when John went to comfort her, she drew back from him. The rejection caused him to be more cautious and reluctant to hold her. As the result of this rift between them, John concentrated more of his efforts on parenting Marcia.

Toddlers learn from their immediate environment; they reach out past themselves to discover. They are seemingly not afraid of anything because they have no experience that tells them they should be. When they do have an unsettling experience, they seek out someone for comfort. When a parent is not available, oftentimes a familiar soft object like a blanket or stuffed toy will do. Many times typical children will develop a relationship or fond feeling with a character or quilt. Unfortunately, Kim had no particular attachment to any kind of object. She felt the pain of touch, the hurtful sound, and was fearful of the unknown. Nothing could pacify her rejection of the environment around her.

As she grew, she sought me out, not for cuddling comfort or companionship, but as a tool. She knew I was her means to get what she wanted, but she could not relate to me as a person. Whenever I sat down, she often came over to push me out of the place where I was sitting or standing. I would move and she then repeatedly pushed me. So there I stood in the middle of the room not knowing what my daughter wanted. She grasped my hand and pulled me to where she needed me to be, neither looking up to my face nor in my direction. She was focused on what she wanted my hand to do. By taking my hand and placing it on the doorknob, she used her hands to manipulate it like an instrument. If I opened the door, she just moved on to the next task—on to the next personal mission—without any

acknowledgement of my part in her progress. Never giving a look of acknowledgement of the deed that was done.

So how does a parent teach a child to relate to others on a personal level? She was far more interested in objects and ambient noises than the people before her, who were usually doing everything they could to get her attention. For us, relating came with time and Kim's habit of working out the concepts on paper.

One day after school during her first grade year, she pointed to me and said, "Mom?" I was so happy and astonished, I said, "Yes." She turned to John and said, "Dad?" He affirmed. She then asked if we were married to which we replied. It was then that I realized that we were going to have to purposefully teach her things that most children realize naturally.

Picture 8.1 My family (7 yrs)

I had made so many assumptions. For instance, I assumed that she would know who we were; that her sister was the eldest; she would know her place in the family.

In third grade she drew a picture of us as a family (Picture 8.1). (It always tickled me because she was so accurate that I could identify the clothes in our closets by her drawings.) The interesting thing was that she illustrated Marcia as a child much younger and smaller than herself. When I explained that Marcia was older, even though Kim really loved her sister, she was very upset. It took her quite some time to come to grips with the idea of a birth order that could not be altered.

Kim's very first verbal utterance was a word she used for her sister's name. I didn't understand what she was saying as she pounded on the bedroom door to get out. As I opened it, Kim shot out of the room to go and join her sister. Marcia was the first person she bonded with. All other relationships had to be hard earned. However, she knew there were restrictions to their relationship. There were times when Marcia wanted to sit by Kim only to have her screech loudly and move away. When they were quite young, it was hard for Marcia to understand that our coping with Kim's unique needs didn't mean that she received special treatment or favored attention. In many ways, Marcia grew up as an only child.

As a family, we have taken all kinds of shapes and forms in Kim's drawings, from ducks to skeletons (Picture 8.2), but, whatever the situation, we've always been shown as warm, loving, and happy.

On paper, we've had fancy parties, wonderful adventures, camping trips—all things we were unable to do in real life.

It was apparent that Kim treasured our relationships and company. These drawings show that even in the early years, when she escaped and ran away countless times, when she could not bear to sit beside us, even then she felt the bond. She had a distinct sense of belonging and attachment to our family unit.

Picture 8.2 My family (8 yrs)

GRANDPARENTS

Many people think that, because I am an artist, Kim's ideas are somehow suggested to her and that I have enhanced or influenced her creative abilities. Nothing could be further from the truth. Even when I directed her towards a subject, the communication gap between us made it impossible to convey what my expectations were.

Because she liked to draw people, I thought it would be nice to have her draw a portrait of my mom and dad. After all, it would be something to treasure and keep. I sat her down and explained the best I could what I wanted her to do and then left her to work. Of course, it took less than a minute. I was speechless when she handed me this paper (Picture 8.3). What tickled me was that I was expecting something very different. I praised her for the wonderful drawing, and the immortalization of my parents was a family joke for years to come.

Picture 8.3 Grandma and Papa (6 yrs)

I think that by the time Kim was diagnosed, all of the grandparents suspected there really was a problem, although they may still have believed that a few spankings would remedy the tantrums. They, like us all, were worn with concern over Kim's inability to do simple tasks or to speak even in small sentences, but their first reaction to the diagnosis was a textbook journey of denial and acceptance.

In their frames of mind, if Kim could hear and understand the word "cookie," she should also be able to hear and understand a directive. My mother's reaction to the fact that Kim might continually echo words and phrases was that it would drive her a little crazy. I can't say that her constant habit of repeating the same words, and making me say them, didn't get to all of us, but at that time I wasn't especially patient with Mother. I didn't comprehend that they also had to go through a grieving process. They also needed a time to adjust; after all, they had never been grandparents to a child with special needs before. This was especially difficult since Kim's autism had to do with the lack of expression of affection and relationships.

John's father had a sister who was deaf, but he just couldn't seem to get a clear understanding of autism. Although his sister had a disability, she didn't throw her body down on the ground and thrash about.

This was new territory for all of us. We each had to sift through experiences to understand what was important and what was not. The grandparents wanted answers, and our vague replies were not satisfying in their quest for a cure for this disorder. There was no formula to point at. No scientific data to cite. Nothing concrete to hold on to. No proven way of successfully treating or extinguishing these strange behaviors. It was frustrating for them.

If Kim had had a physical impairment and was in need of some sort of equipment, they would have moved heaven and earth to acquire it, but autism is so intangible. There was no x-ray to view, no medical test to bear out beyond a shadow of a doubt that it was indeed autism. It was so foreign from anything they had ever known, this incomplete description of strange symptoms that characterized their granddaughter. The hardest thing for them to do was to stand by, helplessly, as we ploughed through the sparse information in that field in search of some plan of action.

The question was, how were they going to relate to a child who had a communication, interaction, social disorder? The grandparents wanted to

be a relevant part of her life. One of the most important lessons that they learned was to let Kim set the pace in this relationship. Change for Kim could not happen fast enough, but, after a while, they came to accept and slow down their expectations. They learned not to make plans for the future that might crumble and crush their dreams of doing things together with her.

When Kim was about three and a half, I asked Mary if we should just not celebrate holidays because they had such a devastating affect on Kim.

"That wouldn't be fair to Marcia," she said. "We can't change the whole world for Kim." That was something Mary continually had to remind me. She did, however, suggest some modifications we could make to enable us to incorporate Kim into our festivities. For instance, we stopped using our treasured, breakable antique ornaments on the Christmas tree and began to make homemade paper, tin, and plastic decorations. That way, no matter how many times Kim brought down the tree, we were not so uptight or upset. We could just set it up again.

Surprises upset Kim terribly, so, whenever she received a gift, we made sure it was not completely wrapped or covered. We developed ways of conveying schedules through photographs and drawings, or, in later years, words of what traditional events would make up our special day. Sometimes we had to let go of certain family customs—not forever—but just until Kim could learn to join in the fun.

These adjustments cut out a lot of stress, although they did not completely put her at ease. Not only were we uptight around holidays, but we unconsciously transferred that tension over to the grandparents. Their houses, too, had to be Kim-proofed—far more extensive than merely baby-proofing. If they had precious breakables or mementos available in arms' reach inside their home, they removed them so that they would not be strained when we came to visit. They knew they constantly had to be an extra set of eyes as well, because of Kim's escaping habits.

My father-in-law had grown up in an era when children were properly dressed at all times. I remember one particular Thanksgiving when I was hosting the dinner and Kim kept stripping off her clothes. Each time I opened the oven to check and baste the turkey, I would hear, "Uh-oh, she's out of her clothes again…There she goes again…Off again…" This happened at least 15 times. Between basting the turkey and dressing Kim, I

was completely exhausted. Finally, I gave up and dressed her in one of John's soft, well-worn T-shirts, but I felt the waves of disapproval.

Years later, after Kim had progressed, her grandpa saw how far she had come and was proud even though she might never stay dressed in the way he would like.

Grandparents were great for support when they had the means to comprehend. They had to trust that we were doing the best we could for our daughters, and they must be given credit for their willingness to be educated and to be flexible so that they could share in their autistic granddaughter's life. Almost every grandparent revels in the small milestones that are reached by their grandchild. It brings fond memories of when they were raising their own children. They love receiving phone calls to keep in touch with the young ones who are rapidly growing each day. When Kim could be prompted to verbalize over the phone, it was bittersweet. She seemed trapped in her echolalia and stuck in a groove like a needle on an old record player. All that she could say was, "…and the sounds, and the sounds, and the sounds…(more than 20 times) goodbye!" The fact that she could speak was wonderful and after so many years of virtual silence it was great, but the grandparents' joy was tempered by the fact that they might never have a meaningful conversation with their granddaughter.

During the holidays, as at all times, everyone in attendance at the house shared the responsibility for watching Kim. Having more than 15 people there really helped to take the pressure off any one person being "on duty" all the time, but it also increased the escape risk. We allowed Kim to slip away into rooms that were on the perimeter of the hub of activity, and every little while I would check on her.

One Christmas morning when Kim was four, she quietly melted away from the group. My mom, sensing that I was about to take my rounds, offered to check on her for me. We soon heard a shriek and a scuffle from the kitchen. Then I heard my mother's voice apologizing to Kim for scaring her. It took quite a bit of coaxing and bribing to get her out from under the table.

Mom started to laugh softly and pointed out paw marks in the pumpkin pies. Sure enough, it looked as though a raccoon had been there. Everyone but Mom and I cleared out of the kitchen and, as the room quietened down, Kim came out of hiding. She sat on my lap, and her grandma

explained that she wasn't mad, just startled. Kim could have all the pie she wanted, and we would just eat around the marks. My sister whispered to me at dinnertime about how far my mother had evolved in understanding Kim's special needs.

Her autistic granddaughter grew up to learn appropriate behavior and has a wonderful affectionate bond with both her grandparents.

In a way, their relationship with their unusual granddaughter taught them, or at least reminded them, of what is important in experiencing life—the small victories.

LOUIE

It is amazing how much heart and soul can exist in a miniature dachshund. We brought the little black and tan dog home before Kim was diagnosed, before many experts had written opinions advising parents of autistic children to rethink having pets. John and I gave the little dog to Marcia as a gift before Christmas. We didn't want a pet to be lost in the shuffle of the holiday. Immediately Kim focused on the puppy. It was not surprising because she had a strange affinity with animals. Marcia named him "Louie," which was not difficult to pronounce, but Kim was non-verbal at the time. She found a way to call him over to the gate that separated them by emitting a high-pitched tone. I can't tell you how or why, but Louie seemed to know that it meant that he should come over to the place where she was. Because of their relationship, as one would expect, she drew an incredible volume of pictures revolving around her favorite playmate (e.g. Picture 8.4 and 8.5).

Even though he was the smallest member of our family, our dog Louie had quite a lot of influence on Kim's art and life.

He was the only figure besides Marcia that Kim could relate to. She wanted his attention. I always had to be in constant watch over her and the pup. She had a tendency to be rough and I didn't want her to get bitten. He, however, could sense that she was not malicious, and endured her rough treatment. He never snapped or was cross even though she gave him plenty of reason to be. After all, even a dog has its limits.

Having the little canine helped Kim to meet some language goals. We encouraged her to use her words to call to him. She enjoyed his attention, even though she didn't particularly care for ours. It gave her a sense of responsibility when she took over the chore of feeding him. The small dog provided something we could not instill in her, that we could not attain for her. He gave her motivation.

Louie was included as an equal member of the family as far as she was concerned. On paper, he and Kim shared adventures together. Whether it was wearing royal garb in Egypt (Picture 8.4), surfing near the beach, or enjoying themselves as Statues of Liberty (Picture 8.6), they always had the best of times. She had a love for her dog that transcended her human relationships.

Kim was tuned in to what Louie's dog family was like. She often drew him as a nurturing, fatherly dog or an orchestra conductor. She even drew his mother setting the table. Scenes like those couldn't be more revealing.

Picture 8.4 Louie and me (10 yrs)

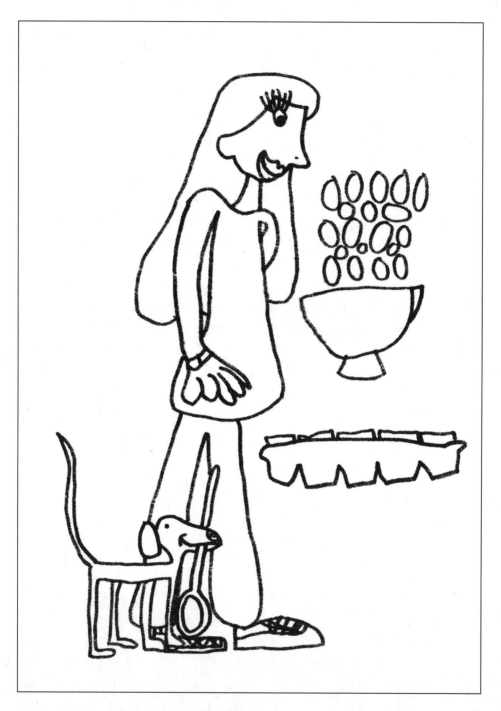

Picture 8.5 Cooking with Louie (7 yrs)

Picture 8.6 Statues of Liberty (10 yrs)

A person can't help but see the warm, healthy family relationships contained in these pictures.

The day came for Kim to graduate from high school. The fifteen-year-old dog wasn't feeling well. He had been blind for over a year but navigated his way in our house from memory. Marcia volunteered to stay with the sick dog while we were at the commencement ceremony. Two hours after Kim received her diploma, our dear precious dog died in my arms. Some say that Louie waited until his job was done to let go of life.

FRIENDSHIPS

Many times when we think of autism, we see an expressionless face, hands not reaching out. We see children not extending themselves socially to make friends, acting aloof, afraid of sudden movements and sounds, and a difficulty in making sense of a gathering of any kind.

In the beginning, Kim played in a parallel manner, not interacting with or joining in to play a game. Most of the time it was as if, for her, no one else existed—or so it seemed. Her drawings, however, reveal the kind feelings and actions when in elementary school; everyone was perceived as a friend. The faces in her drawings appear to be looking at one another, not out of the periphery of each other's eyes. Many times hands are joined or bodies touching—a closeness Kim could not bear. There were countless drawings of Kim giving her best friend a "high five." This physical expression of affirmation is still painful for Kim to this day. The picture (Picture 8.7) shows matching tie-dyed T-shirts and matching shorts, a form of unity or belonging.

On paper, there were peaceful quiet slumber parties. Although Kim has had very few instances when she has had overnight guests, she has sketched a group of friends enjoying the fellowship and close proximity of a sleepover.

As I visited her classroom, many times I would overhear little titbits of conversation about Kim. Most of the time it was in regards to her being an "awesome artist" or "her neat picture." She constantly had requests from her peers to draw a sketch for them. I often found pictures of she and her classmates enjoying each other's company as they played musical instruments

Picture 8.7 Friends (10 yrs)

together, or a teacher-supervised scuba dive. Everyone is enjoying them-
selves, as evidenced by the smiles on their faces. It wasn't just the happiness
these figures expressed but also the depiction of all the characters being
treated equally that is significant.

All of these pictures were developed during the fourth grade year. Kim
showed us that, despite her outward indifference to her peers, she was
warm with the sense of belonging and relationships. She obviously felt
secure about herself and how she was perceived by her classmates.

She wanted to reach out to others, have lots of friends, and be well liked
but it wasn't a burning priority or yearning. The obstacle was that the skills
by which to communicate the desire for friendship and the ability to
maintain a sense of comraderie are very abstract. Thanks to speech therapy,
she can begin a conversation and carry it through several turns, but it takes
more than that to support a friendship.

When the time for adolescence came about, the perceptions of others changed; the same is true of those who are typical. Suddenly teens discover that their world isn't based solely on them, they begin to look at the others around them, making comparisons. Kim was very much influenced by the teen movie media. The usual movie theme revolves around a teen who is regarded inferior by his classmates, which opened up her eyes to the idea that her peers might not view her as an equal. This type of realization happens often as typical relationships shift during the transition time to junior high, but this was not the only factor. She stopped going to visit her friend, refused to go out to the skating parties she had previously enjoyed, and was reluctant to leave the house even to go grocery shopping.

The subject matter of her drawings made a dramatic shift within six months. Suddenly we saw drawings of peers pointing and jeering as Kim has her head held low (e.g. Picture 8.8).

Picture 8.8 The mocking crowd (15 yrs)

It was such an abrupt shift when she no longer trusted the history of friendly feelings. She stopped seeking out friendships with people her own

age and began to strike up relationships with adults. That way, she circumvented all of the teenage drama, hierarchy, and instability. This pattern has held for many years.

I believe the ability to trust will come in time and, as her world expands, she will find she can make lasting friendships through practice.

PERSPECTIVE TAKING

Beginning in ninth grade, tests were administered regularly until graduation. Every student needed to pass them in order to graduate, and many of them had to do with getting up in front of the classroom to give speeches. Kim had no problem with that skill at all. The difficulty lay in one of the subjects that was required to master the series of tests. She was to give a persuasive speech. By the use of reason and artful communication, she was to persuade others to subscribe to what she had to say. Unfortunately, it would require her to examine something from a different point of view.

As I previously stated, she was a child who didn't ask for anything on her behalf, never tried to sway another person to her side, never tried to coax someone into doing anything for her. If she asked a question, the answer for her was black or white, yes or no. She lived in absolutes. The question of "why" was not asked. If she received an answer, she never challenged it.

I wasn't really sure how we were going to get her to try to view issues from the perspective of another. This is one of the most difficult abstract ideas that Kim had to face. As I poured over the box filled with her past works of art, I found many, many pages about having to deal with relationships, but most were within the scope of her point of view.

Autism has the root word of "auto" meaning "self." Her artwork had everything to do with her self, her environment, her perspective. Over the years, she developed an ego on the very pages on which she drew. How were we going to get her to turn the view around so she could see through someone else's eyes?

After she graduated, she processed the information and made this drawing of a girl examining her own outer appearance (see Picture 8.9).

Picture 8.9 Untitled (19 yrs)

It is true that it is a self-examination, but notice that the mask is rotated toward the girl. She is asking an important question: "What do other people perceive?" The removal of the mask is not to reveal what is underneath but it is turned so that it is the girl who is doing the examining. She

Picture 8.10 Inspiration (19 yrs)

wonders if the person that she feels she is inside is the same as who everyone else sees. This is such a wonderful step on the way to discovering another way of looking at life. A person must be able to take another's perspective in order to possess empathy and compassion—to relate to other people.

After Kim showed me this newest colored pencil drawing, I shook my head and said I just did not know how she came up with the inspiration for

these themes. Several days later, I found the pencil drawing (Picture 8.10) in the sketchbook that she uses to jot down quick ideas. Something to be noted: the subject was drawn all on one page unlike earlier work that was rendered on several different pages one frame at a time like a movie. This is another example of her habit of using a reference to a previous piece of work. Indeed, she speaks with pictures.

Kim's artwork was so rich in interactions with people—so loving, caring, filled with embraces and holding hands—which belied what was happening in real life. She found a sense of who she was in the scope of our family, our society, and our world. It was a comfort to know she came to realize these relationships existed; they just needed to come to the surface.

Chapter 9

Memory

Imagine what it would be like not to be able to control the flow of memory in your mind or access necessary information, or to be overwhelmed with unpleasant images or experiences. Like a videotape in your brain that wasn't organized, thoughts that you had stored in your mind kept popping up unexpectedly. On the other hand, perhaps the videotape was not really stored at all or there was no means of recalling information, of bringing it to the forefront of your mind. That would make learning quite difficult. Again, many children at a very early age are able to file various images in a basic order that allows them to access it when possible. It is not something that we teach as parents, but an innate ability that we take for granted.

NATURAL INSTINCTS?

After Kim was born, I took her for "well baby" check-ups where she was tested for typical newborn reflexes. The doctor tested her hand grip, stepping response, startle reflex along with others. She was just fine; however, she did have a problem with the instinct to nurse. I continued to take her for these developmental check-ups until she was a year old. The doctor, considering that she was doing fine, advised me to take her elsewhere for her immunizations. He felt that she was developing appropriately and no longer needed to be seen by a physician.

I didn't realize what was happening when she was so very little, about 2 years old. While at the beach, I saw her pop a handful of sand into her mouth and try to chew it. Immediately, she started screaming and crying,

swiping at her mouth with her hands. I dug the tasteless grit out of her mouth while telling her it wasn't food, but no sooner had I finished wiping her face than she shoved in another handful of sand. We repeated this scenario several times before I was able to distract her with something else. Didn't she understand when I told her the rocks and shells weren't edible? Why wasn't she learning? Couldn't she remember that just moments ago she had done the same thing and had an unpleasant experience?

At the age of four, Kim lacked a basic instinct to wince at a perceived danger. Kim possessed no type of "flinch" response. Sometimes she wandered about, not taking in much of her environment past about 10 feet of space. She did not notice a group of children rushing toward her, an object on a collision course, or how close she was getting to a child going back and forth on a playground swing. There was no initial startle response, no squint, no reflex towards protecting and defending herself. Therefore, I had to be ever vigilant to make sure that she did not put herself in the way of danger. When the sunshine struck her through the windows of our car, she cried out, but did not have the instinct to raise her hand to shield her eyes. This not only happened once but numerous times.

As Kim had this wonderful photographic memory, why did she not anticipate or identify hazards? Even though she must have had a catalogue of experiences during her development, there was no applied memory.

While she sat in the back seat of our extended cab pick-up truck, she had no instinct to shift her body or compensate for the pull of force as we went around corners. If we drove over uneven or bumpy roads, her head bounced against the padded interior. Out of concern that her brain be roughly jostled, I placed my hands between her head and the truck. After getting whacked a few times, you would think that Kim would adjust her position so that it would be less likely to happen. Strangely enough, even at an early age, without being taught, we learn to physically compensate for the forces on our bodies when we ride a horse, travel in an automobile, or ride a bike. We learn through trial and error, and then make the appropriate adjustments. Kim took a much longer time than her peers to learn what they seemed to pick up naturally.

The preschool time in the Early Intervention Program was spent mainly on developing verbal or augmented communication. I felt that, after the ability to speak was established, most of her skills would fall into place. The method chosen to teach Kim communication was predomi-

nately focused on modeling language for her and asking her open-ended questions.

At this point, she did not ask any questions and rarely gave more than one-word answers. The "who," "what," and "why" questions were just not following the beginning of language. Perhaps that is the way typical children begin to organize and file information.

Several pages of work were generated based on the poem, *'Twas the Night Before Christmas*. These drawings are important because they contained small clues to Kim's thought processes. She was recording the facts as they were related to her in the story.

The poem states, "Not a creature was stirring, not even a mouse."

Notice in Picture 9.1 that the mouse at the left of the fireplace literally cannot "stir." It is bound and gagged—a very concrete way of interpreting that phrase.

Picture 9.1 Not a creature stirring (5 yrs)

All members of our family have their own stockings, including the dog. That is a marvelous way of showing one-to-one correspondence. The stockings are filled with appropriate gifts, such as bones for the dog. Notice that the lines meet neatly. For a child of five, Kim shows great maturity as an artist. Her strokes are sure—not shaky. The "Up on the housetop" drawing (Picture 9.2) shows that she was paying attention to the story. Because there are eight tiny reindeer on the roof, we knew she could count. Each deer has the appropriate number of legs, feet, and antlers. I love the three-dimensional quality of the deer. Something that was very important for Kim to show in her artwork was depth. This drawing was not symptomatic of perseveration; the animals are treated individually. The drawing shows their legs in different positions and an overlapping of their heads. So many of the stories were read to her, many themes from television shows and movies were recorded on paper. It was important enough for her to record, a way to show what made up the interior of her mind. But

Picture 9.2 Up on the housetop (5 yrs)

was that all, just the regurgitation of stories and visual information? There was no doubt from viewing her artwork that she reflected facts that she had learned, but could she ever do so in a timely manner using words? Like a type of instant recall.

After going on a fun- filled second-grade field trip, the autism specialist asked Kim questions about her day. After considering the question and quite a few prompts from classmates, she started to relay the information in the present tense as though she were narrating a videotape of events in her mind. There was no stopping her once she was started and if questions were asked she could not give an answer. It was through her drawings that we could see that she was recording the visual information from her mind. While picking through the huge amount of artwork that was developed at that time, I have discovered several subjects that are rendered in a type of two- to three-frame movie. Her body of work during elementary school was largely derived from recording television shows, movies and characters. Judging from her artwork, a large part of her memory was evidently by rote. If she had an established memory and a developing communication system, then why couldn't she apply what she remembered? There was apparently a disconnect between memory of events, people and applied learning.

A BREAKTHROUGH

Right away, during the first week of the third grade of school, Kim had a significant breakthrough. As she was riding in the car, we rounded the corner that had a palm tree at the side of the road.

Her eyes lit up with recognition, and she blurted out, "That's a Mexican tree! Like the tree at Denny's (restaurant). I went to Denny's with Mary. I didn't eat anything."

I tried to pay attention to my driving but at the same time draw out further information from Kim. I didn't want to appear too excited, distracting her and breaking the train of thought. This was not echolalia, but a spontaneous thought. I might not get another moment like this one. All of the information was true and she hadn't been asked about it, so it could not have been a thought that was implanted. We hadn't related the incident in a

conversation or reminded her of it. This was significant because at the time this event occurred she was virtually non-verbal. I asked her the names of Mary's assistants. She had difficulty forming the words.

"Ebie and El…El…" she stuttered.

"Helga?" I offered. Kim looked pleased.

Evie had been one of the classroom aides in Kim's preschool room. The way Kim pronounced her name was "Ebie." Helga's name was much harder for Kim to pronounce, especially because, at that time, she was placing an "f" on the end of almost all of her words. She called her "Elga-f."

The nearby Denny's restaurant had a palm tree out front. Once or twice a year, the preschool class was invited to go to breakfast. It's true, she didn't eat. She spent most of her time drinking syrups.

This breakthrough was extremely significant because, up to this point, when Kim was asked to relate an event from the past, she expressed it in the present tense as though she were reliving it. What seemed to have preceded this event was that she had been watching the Disney movie, *The Santa Clause*. She observed the little boy's frustration at his father's lack of memory of their trip to the North Pole. The child in the movie tries to jog his father's memory and shouts, "Remember!" The character then seems to recall everything that his son is talking about.

Kim watched this segment over and over, analyzed it, and incorporated the word into her speech. She asked, "What does 'remember' mean?" We tried to explain it many times, many different ways. She was searching for key words in each definition and, even though we directed her to the dictionary, she still sought out clarification. Unfortunately, she didn't ask the same person each time. Therefore, she received the same type of explanation using different words. She was frustrated because there was no way for her to make an absolute template from which to draw.

Again, I felt that because there was such an incredible breakthrough with her memory, we would be able to ask questions and get answers. It seemed so simple because she had been able to do it once, and I thought a floodgate of memories would pour out. Slowly, every now and then—every few months—she would have a recollection of an event, usually jogged by sight of an object or a place where she had been.

Much like a capsulized bubble, the memory broke free, rising to the surface from some place very deep within. The remembrance did not lead

to new paths, or new avenues of conversation. It was autonomous and contained with no way to wring out any more titbits of intelligence. The only information that was available was only for that moment. We tried to ask as many questions as we could to ascertain just how much she could remember, yet at the same time we didn't want to overwhelm her to the point that she would feel frustrated. We were very careful not to implant false memories by suggestion or our line of questioning. Because of that possibility, we took great care to keep her memory pristine so that we could be sure that each memory was indeed a true account. It was a relief to know that she could recall and relay an event, but it was exasperating not to be able to assist in developing a way to release whatever was blocking the pathway in her mind.

It was evident from her drawings that she had rendered all along that she had a near photographic memory. In second grade, Kim was scared of some girls who thought it was fun to run after her. I don't believe there was any malice in their actions, but nonetheless it upset her. I found a drawing

Picture 9.3 Being chased (6 yrs)

on the floor that showed she didn't like being chased by the other children while on her way home from school. She didn't know the names of anyone involved, but, by looking at the characteristics of the children in her drawing (Picture 9.3), I was able to contact those individuals and ask them to stop. Kim's drawings were so accurate that they were taken seriously. It was like a person who speaks the truth; her artwork gave her that type of credibility and respect.

Years went by with intermittent successes whereby Kim told us of small impressions she had of events. Her expression of what occurred in the past is very interesting. As with her drawings, the words and phrases she uses are almost poetic. While summarizing these events, she usually talks about peripheral subjects. It would only make sense that her view of the same happening would be different; it was recorded in her mind from a different perspective. With her head cast down or away from what was usually taking place, her attention was directed elsewhere. She could describe minute details such as the clothes she was wearing at the time (see Picture 9.4) showing a broken button on the jacket, or an obscure leaky faucet that she happened to notice. Many of these details couldn't be confirmed because none of us had that keen a memory; however, by looking at photographs much, much later, we found that Kim was right.

BAD MEMORIES

We were thrilled with the fact that Kim's memories were emerging. But of course, as with everything, when you let in the good, you open yourself up to the bad as well. It didn't matter whether it was during the day or night, Kim could be suffering from remembering something that was not pleasant. Sometimes there were distressing images of people she did not like for one reason or another. Like everyone does, she struggled with her imperfections, her feelings of humiliations, her perceived lack of success. Whatever was causing the problem, it was causing her to suffer. There was no way to remove the thought, so we distracted her attention by playing cheerful cartoon videotapes.

It wasn't as though we could talk about the problem and process the unpleasantness in that manner. What was worse, if we tried to address the issue, it only made the memory more ingrained and took hours longer to

Picture 9.4 Making a snowman (6 yrs)

distract her mind from the thoughts that caused so much distress. That sounds like an extremely simple solution, but it wasn't. It only made sense to replace an unpleasant image playing in her mind with a more pleasing thought. For quite some time, many years in fact, this method of substituting one stimulus for another worked very well but it did not cure the problem. Unfortunately, the same unpleasant picture or video presented itself to the forefront of her brain. She didn't have the skill to repress the memory because she possessed no ability to exert control to regulate the thoughts that rose to the consciousness of her brain. There was no shutting off the flow of these memories, just diverting the stream.

SIXTH GRADE "KEEPING HER MEMORIES"

This group of drawings developed from an obsession with *The Phantom of the Opera*. Kim has had a love affair with the characters for years. I wasn't aware that these drawings belonged together until Kim pointed them out.

When she saw the sheer volume of artwork I had collected over the years she had been an artist, she said, "Thank you for keeping my memories." I really didn't know what she meant. She explained that these "Opera" drawings (e.g. Pictures 9.5 and 9.6) were a way of remembering a movie. She had no communication or other motive to sketch them out other than to record a memory, although, in looking at the drawings, you would think there was a highly emotional underlying theme.

Picture 9.5 *Phantom of the Opera* 1 (11 yrs)

Picture 9.6 *Phantom of the Opera* 2 (11 yrs)

Kim's drawing of her memory gallery was a puzzle to me. Did the figures reveal feelings buried deep inside? Was she crying out for help? Was she examining emotions through the eyes of classic artists? The answer is yes. Yes, to all of these questions.

Picture 9.7 Gallery of memories and tribute to the masters (11 yrs)

A few of the drawings are Kim's own compositions (see Picture 9.7). The sculptures on the table are actually clay objects she designed in clay class at school. A couple of these drawings are influenced by the masters, Picasso and Edward Munch as well as Henri de Toulouse Lautrec. I find it interesting that she is showing us that she is viewing her memories hanging on a wall, separate from her being, recorded and encased in art. Not only does she speak with pictures, but her memory is stored there as well. She wanted to share this with us so we could understand that this is how she views her memories.

SEPTEMBER 11, 2001

What more could be said about that tragic day? I couldn't attempt to adequately express or characterize how anyone felt on that day. I was

concerned, as all parents were, about how this affected our children. The non-stop television coverage and the enormity of the event were over-whelming. We were all trying to sort out the many types of feelings, including anger, hurt, uncertainty, and concern for others (including my niece who was a stewardess). The sense of emotions that hung in the air was so heavy and thick, you could cut them with a knife. I watched for signs of extreme stress in both my girls' faces and constantly checked on their mental well-being. On the other hand, I did not know if Kim could actually take in the magnitude of the incident, the cost of so many lives. It took many months for all of us to sort out just what happened. Kim had a habit of keeping a portfolio of paper with her at all times so that when she had a spare moment she could draw. Not wanting to invade her privacy, but out of concern, I asked for permission to go through her drawings and found just one drawing to record what had happened.

This drawing (Picture 9.8) was rendered a couple of days after the event. The man is wearing a mask because, at that time, no one knew who orchestrated the event. The man aims the planes at the buildings. This was Kim's way of interpreting what had happened.

Picture 9.8 September 11, 2001 (13 yrs)

DIFFERENT SPECTRUM

One evening just before school finished for the summer of her freshman year of high school, Kim handed me this drawing (Picture 9.9). She gave me a hug goodnight and went to bed. I called after her and said that I would take a look at it when I got the chance. An hour later, I sat down with a cup of coffee to relax and enjoy her drawing.

Picture 9.9 Light spectrum (15 yrs)

At first glance, I was impressed with the colors that she used as if they were an artist's color wheel. I chuckled to see that she developed the concept by using portraits of herself. I thought it a clever idea, but then something caught my eye. A mistake! Kim didn't usually make such elementary errors. Still it was a fun drawing. I would have to talk to her in the morning, I thought.

As she was getting ready for school the next morning, I approached her about drawing a copy of the same drawing, only this time, I said, she could make a small correction. She argued that her original was accurate. I told her I would like to use the amended drawing in the book, but, again, she said there was no mistake.

I said, "This is a color wheel."

She nodded.

"Blue and red make violet, and blue and green make turquoise, but red and green don't make yellow. You see, Kim, yellow is a primary color," I said gently. I didn't want to make her feel sad, and it was such a nice picture.

"But Mom, red and green *do* make yellow," she said adamantly, "when using light."

I searched my memory. In science class, Kim and her classmates were learning about the spectrum of light, and that's why she was so quick to point out that she was correct. I confirmed the facts with Marcia, and Kim, indeed, was right.

This was a very good example of trying to relate to Kim's drawings by applying what we think we know to her artwork without being aware of any background. I immediately compared it to the artist's color wheel that I am familiar with, and missed the point completely.

There is usually meaning to what she creates and why she creates it. She had learned a new concept in science class in the weeks prior, applied it to herself (literally), and through her own portraits discovered a new way of thinking about the light spectrum.

DIFFERENT TYPE OF HARD DRIVE

It was at this time that I realized Kim was using her drawings in a similar way to a computer's external hard drive. She was recording the images concretely on paper in order to preserve them. This was the way she chose to store data in a different place. This was important.

When it came time for her to take a college credit course as a senior in high school, the question arose as to whether she could finish the huge amount of reading material required in the class. The reading level required was not really a problem. At this point, Kim was a slow reader because she had only started recreationally reading in sixth grade. I had to bribe her with candies and promises of special outings for every chapter that she finished. The love of reading and discovery just wasn't there. She did not have the speed to be able to complete a book in a timely fashion, let alone process the events and characters in the story. How were we going to accelerate her ability to view the words and soak in the substance vital to the class? It would be unfair to Kim to skip over the course just because of that element alone. I assured the teacher that it could be done, even though inside I didn't have a clue what we were going to do.

At first we bought some audiotapes that were adapted from the book, but it did not read word for word from the text. This was a problem because she couldn't follow along in the text and wouldn't be able to read the words as they were being read to her. It also skipped much of the important information that would be in the tests. I decided to read the thick paperback books out loud to her myself. However, there was still the problem of not being able to connect the visual words. I suppose that I could have bought another book for her to read along as I said the words, but that would not have solved her difficulty to summarize what was being read concisely—a skill that she struggled with.

Marcia came up with the suggestion of using sticky notes or Post-it notes™. I could read a portion, tell Kim to sum it up in a few words, write it on a note and stick it on the page so that the paper piece stuck on the outside edge and would be quite easy to turn directly to the page if she needed to refresh her memory. This was the way that we worked this situation. She really wanted this class so she was motivated to do what was required to get the work done. We set aside hours every night to get the

reading done. Unfortunately, it takes longer for me to read out loud than it does to read to myself. All of this was done on top of reading books to her for language arts class, but Kim was committed and it was the best accommodation that I could come up with.

Time for testing her knowledge of the setting, characters, and events came. By using the sticky notes, we unknowingly had summarized the book and therefore made her recall more organized. She could physically see what happened in the beginning, middle, and end. She could hunt for certain parts of the story that she knew would be in the test. The wonderful thing is that she didn't have to flip through pages, wasting time, trying to locate pertinent passages. It created an organized way to study and a concrete manner of gathering the information.

Memory is a very important tool if it can be accessed. We use it to not repeat the same mistakes of the past. It tells us who we are and helps us to define where we are going in the future. Through her paper memories, Kim found herself and established an ego with a sense of pride.

If you met Kim now, she would appear to be a typical teenager. As a result of years of speech therapy, she can look you full in the eye. She has learned through visual cues to respond when asked a question or to return a greeting. When Kim approaches me to talk about a subject, it is usually something she has been ruminating over days or even weeks ahead of time. Because she has had time to construct the major idea and prepare for any follow-up questions, she is very articulate about what she wants to discuss. She can recognize the irony in children's animated cartoons, the figurative language in poetry or Shakespeare, and has questions regarding colloquialisms in our everyday speech.

CRAVING LIBERATION (IN HER OWN WORDS)

My favorite mediums are pencils and, sometimes, color pencils. They provide the precise detail that I crave. I sometimes emphasize features of the face but mainly the soul. In some of my artwork, I include personal references to symbolism along with movement. My favorite technique is repetition because of its complexities, like the rhythm of a song or repeated message in a story.

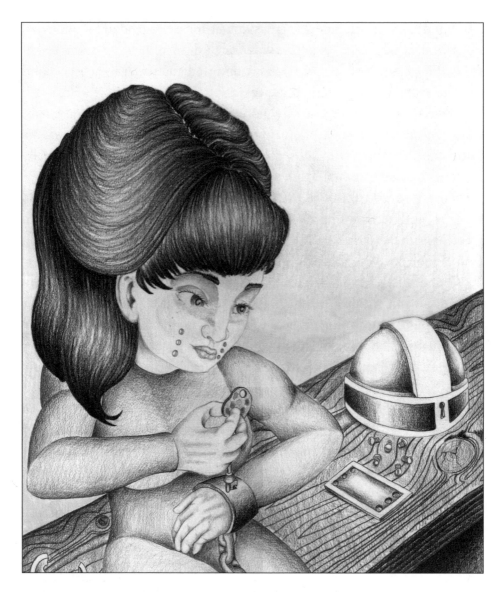

Picture 9.10 Craving liberation (17 yrs)

Art plays many roles in my life. It helps me express feelings, communicate, and heal my wounds. Some of the disabling effects of my autism complicate my ability to join social groups, to perceive complex emotions, to adapt to ever-changing environments. However, along with my disability, comes a great gift. I have always had incredible depth perception. Going through the drawing process is like thinking out loud—but on paper. I record my hopes and dreams as well as circumstances that make life

difficult. As a result, I process the information and put the ideas into perspective. For years I have been chained by autism, and art is my key to unlock my inner desires (see Picture 9.10). First, I released my voice and my mind, putting behind me many effects of my disability.

My art brings people through my mind by plunging through the barrier of ignorance to reveal my world on the other side. After many years of creating, I realize that I have become a liberated autistic individual not confined by mere words.

Conclusion

This book is not in any way the definitive word on our autism experience. The focus of this book was more about Kim, her special needs, the artwork she was compelled to create, the communication found in it and how her artwork was used as a window to her world. Without the ability to express her thoughts, her motivations and ideas, she would have been, and would likely still be, at the very least misunderstood. The artwork that she rendered not only opened up educational opportunities, but also gained her the respect of a community.

As her ability to communicate through art developed, her body of work involved the expression of a wide range of feelings. Just as she had explored the dimensions of the human body when she began, the search for meaning in emotions took the same analytical path—examination from all sides of the intangible, illusive feelings that needed to be processed and neatly filed away, each in its place. There were hidden meanings—pictures within pictures—that gave the viewer more than just a pause to glance.

There is no way to separate the art from Kim or Kim from the art. The same is true of her autism. It is the total and whole of who she is.

Kim came home from high school one day with an excited twinkle in her eye. After putting her books away and getting a snack, she began to tell me about her day.

"Mom, one of the teachers asked me a question. He wanted to know what I wanted to '*be*' after I graduated high school. I realized he was wanting to know what sort of vocation I was interested in pursuing, what kind of goals for the future, what did I want to achieve with my life. I just told him that I didn't know."

She told me that, after reflecting on all of her accomplishments, her struggles in overcoming many of the debilitating effects of autism, and her efforts to show that autistic individuals have much to contribute to the world, she had come to a conclusion in reference to his question.

"Oh, and what is that?" I asked.

"When he asked me what I wanted to *be*...What I wanted to tell him is...that I feel...I already *am*".